IMAGES
of America

WESTLAKE

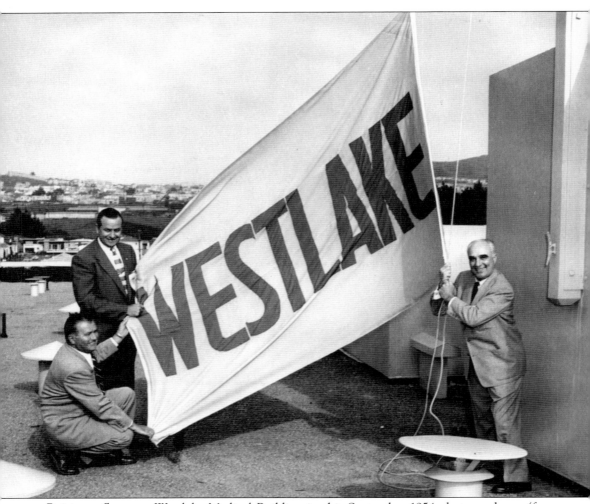

Raising a flag atop Westlake Medical Building in this September 1954 photograph are (from left to right) Doelger company executives Bernardino Poncetta, John Doelger, and U. R. "Jack" Kendree. When asked why the banner was so large, Westlake officials responded, "When you don't feel well, you don't want to hunt for the medical offices." The flag was retired from use a few years later after becoming wind-shredded. (Doelger Estate photograph.)

ON THE COVER: April 1962 brought a large crowd of fashion buffs to Westlake Shopping Center's center court as the latest in spring styles from local stores were modeled. (Doelger Estate photograph.)

IMAGES
of America

WESTLAKE

Bunny Gillespie

Bunny Gillespie (signature)

ARCADIA
PUBLISHING

Published by Arcadia Publishing
Charleston SC, Chicago IL, Portsmouth NH, San Francisco CA

Printed in the United States of America

Library of Congress Catalog Card Number: 2008926276

For all general information contact Arcadia Publishing at:
Telephone 843-853-2070
Fax 843-853-0044
E-mail sales@arcadiapublishing.com
For customer service and orders:
Toll-Free 1-888-313-2665

Visit us on the Internet at www.arcadiapublishing.com

This book is lovingly dedicated to Ken, Perky and Bill, Stephanie and Adam, Amanda and Molly, and Andy and Karen, without whose prodding and constant encouragement Images of America: Westlake could not have been written.

CONTENTS

ACKNOWLEDGMENTS

Appreciation is especially extended for the gracious permission of Ed King, administrator of the Doelger Estate, for use of long-treasured photographs generated with historic foresight under the direction of entrepreneur Henry Doelger. All images in this book, except where individually cited, are from the Doelger Estate.

Gratitude is also directed to Georgette Sarles, president of the Westlake Merchants Association and the Daly City/Colma Chamber of Commerce; Perla Ibarrientos of the Fil-Am Society; Daly City paparazzo Frank Franceschini; and Kimco Realty.

Thanks also to my editor, John Poultney, who also served in that capacity for my Images of America: *Daly City* book.

Additionally I wish to acknowledge the memory of the late Henry Doelger with appreciation for his friendship and for the enduring legacy of quality living that he provided for all those continuing to live happily in a Doelger-built home.

INTRODUCTION

The Westlake area of Daly City, California, is evidence of a modern rags-to-riches story that uniquely brought thousands of affordable homes to the northwest corner of San Mateo County after World War II. Daly City, now the largest city in San Mateo County, increased in size almost by half in 1948 when entrepreneur Henry Doelger's remarkable and historic Westlake housing and commercial development was annexed to Daly City by public vote.

To this day, the names of Henry Doelger and Westlake are synonymous. To speak of Westlake is to speak of Henry Doelger. There were forerunners to Henry Doelger in the north county, but none had contributed to the quality of life in Daly City on such a grand scale as Doelger.

In 1853, an Irishman named Robert Sheldon Thornton had eyed the area and started a move south from San Francisco, followed by others who established farms, homes, and businesses in the area. People thought Thornton would have been wiser to have settled closer to the hub of San Francisco. They were wrong.

Fifteen years later, in 1868, John Donald Daly, a Bostonian with a sense of adventure, gave up a job on a south peninsula dairy ranch to settle on land that was to become his namesake city. He established a hilltop dairy of his own and started a family. There were those who thought the idea of transporting milk and dairy products into San Francisco would not be profitable and that the sparsely populated area nearest Daly's ranch could not support such an endeavor. They were wrong. When Daly City incorporated in 1911, citizens named the city in his honor.

Approximately 80 years later, Henry Doelger was to bring dramatic changes to unincorporated land in San Mateo County.

In the 1890s, Westlake had not yet been envisioned. The area in which it would be located, Daly City, was a tiny, tight-knit, unincorporated community just south of the San Francisco–San Mateo County border line. San Francisco was a thriving and vibrant metropolis, still prospering in the afterglow of California's Gold Rush almost a half century earlier. San Francisco was soon to be recognized as one of the largest cities in the United States. Businesses were successful; living was good.

As the close of the 19th century neared, Henry Doelger was born in an apartment in back of his parents' small German bakery. The year was 1896. The shop was located at the corner of Mason and Pacific Streets on the fringe of San Francisco's famed Barbary Coast. Henry was one of five children born to John and Julia. Both were German immigrants. His maternal grandfather had come to America in the 1870s to open a small cabinet shop.

During Henry's earliest years, Wyatt Earp, the legendary sheriff of Tombstone, Arizona, was living in San Francisco. He had forsaken his saddle horses for harness racing and capitalized on his celebrity to referee world-class boxing matches. The second Cliff House overlooking the Pacific Ocean was opened, the first one having been lost to fire. The first automobile would soon take to the streets of San Francisco. Scottish gardener John McLaren was already busy developing dunes into public gardens to be known as Golden Gate Park. The park, at that date, was the largest ever transformation of San Francisco dunes into desirable acreage.

As a boy, Doelger remembered years later, the dunes were to him what the Mississippi River was to Tom Sawyer, a never-ending source of wonder and mystery and a playground upon which he would one day build his dream castles.

In 1905, Henry's parents opened a small grocery store on Seventh Avenue in the Sunset District. Although there were few homes in the area, Papa Doelger ignored skeptics who joked,

"He's planning to sell groceries to the jackrabbits." In the spring of 1906, the area around John's store became a mecca for families who had relocated after having lost homes in San Francisco's terrible earthquake and fire. From his father, Henry learned about the importance of making money, taking risks, and planning for the future. The wisdom remained with Henry for the rest of his life.

At the age of 10, Henry searched through piles of earthquake debris and fire ruins to look for window weights or other scrap metal to be sold to local junk men. Mondays, however, were reserved for collecting tossed beverage bottles from behind saloons, restaurants, and wherever weekend revelries might have occurred. Hauling bulging burlap sacks of recyclable materials to junkyards provided a satisfying amount of pocket money.

While Henry was in eighth grade, his father died. To help family finances, Henry hired on as a delivery boy for the Modern Grocer, so named because all deliveries were made in a 1906 Reo automobile. During World War I, Henry served as a quartermaster in the U.S. Merchant Marine. Home again, he opened a hot dog and enchilada stand opposite the baseball field in Golden Gate Park. "I served the best in town for a nickel the copy," Doelger recalled years later.

While combining his activities as a gofer and junior salesman in his brother Frank's real estate office, Doelger learned the fundamentals of buying and selling property. He remembered his father's advice on taking risks and planning for the future.

In 1922, the budding entrepreneur invested $1,100 in a parcel of land at Fourteenth Avenue and Irving Street in San Francisco. He had heard a rumor that a movie house was to be built across the street. He reasoned that the property might increase in value. Two months later, Doelger sold the property for $25,000, realizing a tidy profit.

In 1923, at age 27, Doelger opened his own real estate office. Three years later, he purchased 11 square blocks in the Sunset and became the district's largest landowner. As the real estate market declined, he donned carpenter overalls and started building homes to protect his investment. In 1926, he built and sold 25 homes, a major achievement for the time. When the Great Depression hit, Doelger suspended building, but his faith in the future continued. By 1932, he was back in business and was again conquering the Sunset's sand dunes. Nine years later, he was described in construction journals as "America's Largest Home Builder."

In March 1941, Doelger was quoted in the *San Francisco News* and lauded for his developments on the dunes. "San Francisco dunes will soon be history," headlined a story in which the entrepreneur recalled his earlier days. "In the old days there was plenty of room for expansion in the Sunset District," Doelger soliloquized. "Block after block of barren sand dunes almost as far as the eye could reach.

"I've always loved the dunes," Doelger declared. "Some day, we will see the last of the dunes. Every block from San Francisco's Twin Peaks to the beach will be solidly built up with homes. I will be proud of the part that it has been my fortune to play in this great development."

There was a hiatus in construction of public housing in the San Francisco Bay area during World War II. Doelger's expertise was diverted to working with the U.S. Army Corps of Engineers in the cities of Oakland, Vallejo, and Benicia. He is credited with supervising construction of 3,000 homes for defense workers in San Francisco, South San Francisco, and Oakland.

After World War II, he returned to private enterprise and built 300 flats and apartments in the Sunset and Richmond Districts of San Francisco.

As he had predicted, Doelger did run out of dune space for home starts in San Francisco. Nearing the age of 50, he turned his sights on the dunes sprawling over the undulating open spaces of neighboring Daly City. He would call his new development "Westlake."

In 1945, Doelger purchased 1,350 acres from Spring Valley Water Company in the mostly uninhabited northwest corner of San Mateo County. He spoke of building homes on the property, although others saw the land as only usable for the existing hog ranches, truck gardens, and scrawny native vegetation. He paid $650,000 for the waiting land.

Doelger envisioned an area of affordable homes for returning service veterans and their families. Concerned friends thought Doelger was out of his mind to set his sights on such

formidable terrain. They questioned his plan to build a housing development so far from the city of San Francisco. The political climate at the time was not totally in accord with the idea of annexing Doelger's land to Daly City. He proved his naysayers and detractors wrong.

The dunes around Daly City were sparsely used in the mid-1940s when Doelger started negotiations to lavish his constructive interests in San Mateo County. The area contributed little to the local economy. A longtime history as an agrarian society satisfied the needs of locals and continued to supply field produce and flowers for San Francisco markets. Riding stables perched on high western slopes overlooking the Pacific Ocean. The coastal land offered boarding for horses, horses to hire, magnificent views, and access to romantic sunset rides along the edge of the splashing waves. In the earliest years of the 20th century, the Ocean Shore Railroad (OSRR) had chugged through the area, taking passengers from San Francisco for thrilling excursions southward along the rugged San Mateo County coastline. The OSRR was long-gone by the time Doelger turned his attention to the area, but an extended "battle of the hump," regarding the line's long-abandoned right-of-way, was to ensue near Southgate Avenue. Litigation to curtail Doelger's development was heard in courts for many years.

Neither embracing a lake nor situated west of vaguely neighboring Lake Merced (Laguna de la Merced), the area known as Westlake lies to the south of the scenic body of water. The name chosen by Doelger was a conundrum contrived by the builder, allowing him to offer several explanations over the years. A favorite was his, "It was named for my cousin, Mae." He referred to the glamorous sexy blond Hollywood movie star Mae "Come up and see me sometime" West, who may or may not have been, in reality, his cousin.

The area around Lake Merced had originally been inhabited by Ohlone Indians. Spanish exploration scouts had visited the lake in 1774, looking it over as a possible site for one of Fr. Junipero Serra's chain of California missions. The padres named it "The Lake of Our Lady of Mercy." Later it became simply "Lake Merced." An abundance of fleas around the water, so reports tell, made the site less than desirable for prospective land users.

A moment of historic and political fame occurred near the lake in 1859, when a hospitable farmer made his property available to host what has been described as the "last legal gun duel in the State of California." Almost straddling the San Francisco–San Mateo County line, Broderick-Terry Duel Site Park is maintained by the City of Daly City. The park now marks with concrete pylons the spots where U.S. senator David Broderick and California Supreme Court justice David Terry faced off and took aim on a mid-September morning. They had held differing opinions regarding California's participation in the impending American Civil War. Broderick died from the encounter. Today the site is popular as a romping area for Westlake dogs, easy strolling, and picnicking.

Doelger's Westlake not only was to provide housing for thousands of families; it also provided employment for service veterans and scores of people who had been released from wartime defense production jobs and preferred to remain in the Bay Area. They flocked to developing Westlake.

During the 1950s and 1960s, Westlake became to California what post–World War II Levittown, with its massive affordable housing development, was to New York. Doelger was reported to have invited his early cohorts and investors to "Help me build a city."

Though the suggestion had been brought forward over the years, the area that Doelger developed was never named Doelgerville, or Doelgertown, or Doelger City. No street in Westlake is named for Doelger, nor is a school. Doelger himself did not seek or approve of such recognition. Currently a community senior center bears the name of Doelger and a former school building utilized by artists is named for him. Small busts of the builder are displayed in both locations. As it was written of the great Christopher Wren, architect of London, "If you wish to see his monument, look around you." The same might be said of Henry Doelger of Westlake.

In 1978, Doelger died in his sleep while staying at the small town of Borgaro, near Turin, in Italy. He had been cruising the Mediterranean on his 140-foot yacht, the *Westlake III*, from Monaco. With him was his longtime friend retired San Francisco police inspector Frank

McCann. Doelger was 82. A memorial service was held at Our Lady of Mercy Church, just a few blocks from his Westlake home. Among the accolades were references to Doelger as "California's Henry Ford" and "a stalwart of the middle class people" who was "the first to make it possible for them to afford homes." A resolution was issued by the State of California memorializing his "illustrious record of personal and professional achievements."

In spite of earthquakes and passing years, Henry Doelger's Westlake (Doelgerville?) remains today as one of the premier dwelling areas in Northern California.

One

"WE USED TO LIVE IN THE AVENUES"

For many Westlake home buyers, the Doelger experience did not start in Daly City. Almost like lemmings, a significant number had followed "America's Largest Home Builder" south to nearby Daly City in the northwest corner of San Mateo County after having enjoyed Doelger-built homes in San Francisco's Sunset District. For years, "we used to live in the Avenues" was a popular phrase used by early-on Westlake homeowners. Doelger, of course, welcomed these second-time purchasers.

Some of the first Westlake home purchasers had been friendly with Doelger years before he entered the home construction business. The "I knew him when" people were proud to boast of their long acquaintance with him. He had become a millionaire several times over, and his aura of success was enjoyed vicariously by close and casual friends alike. Some might have purchased bread or pies from the German bakery owned by Doelger's parents. Some might have searched with the 10-year-old through piles of rubble created by the 1906 earthquake and fire to find items that could be sold to junk men and metal recyclers.

After the 1906 earthquake and fire in San Francisco, the Sunset provided a haven for people seeking less crowded neighborhoods and streets than those in the bustling and vibrant inner city. They might have patronized the mom-and-pop grocery store then being operated in the Sunset by the elder Doelgers. They might have enjoyed the hot dogs and enchiladas Henry sold on a street corner near the entrance to Golden Gate Park during his late teens.

The Doelger saga of success in the sandy Sunset had started in 1922 when he parlayed $1,100 of venture capital into $25,000 two months later. Doelger had been tipped that a movie house would be built across the street from a certain lot and property values might soar. He bought the property. Prices did soar. Doelger was on his way to fame and fortune. He was 26 years old.

Years later, Doelger Estate manager Ed King would recall, "When the 1929 Depression struck, the young realtor was stuck with land no one would buy. So he borrowed money and started building homes."

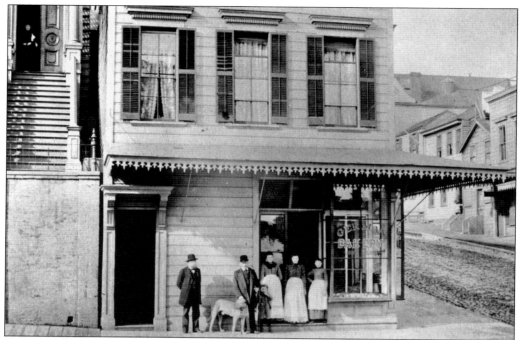

The sweet smell of success, or perhaps German strudel, might have wafted from ovens of this German bakery at Mason and Pacific Streets in San Francisco when this 1891 photograph of proprietors John and Julia Doelger and their family, including a pet dog, was taken. Five years later, the couple would welcome the birth of their second son. They would name him Henry.

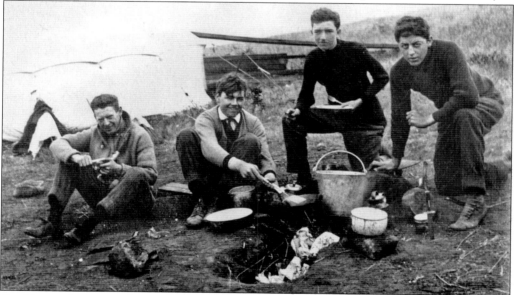

Possibly prophetic was this cookout on San Mateo County coastal dunes in 1912, when Henry Doelger (right) and friends enjoyed fish cooked in a fire pit dug into the ground. Years later, Doelger would remark that the coastal dunes were to him what the Mississippi River was to Tom Sawyer—a place providing adventure, wonder, mystery, and dreams that might one day turn into reality.

Ocean-caught fish to fry were on the mind of young angler Henry Doelger in this 1912 photograph, taken during a San Mateo County coastal camping adventure with school chums. Thirty-five years later, Doelger would have larger "fish to fry" as he returned to the coastal sand dunes with his construction company to launch a massive project that would become Westlake, replacing acres of dunes in Daly City.

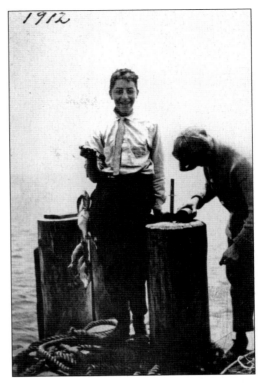

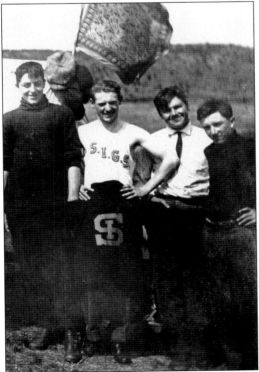

High-button shoes, wool caps, and St. Ignatius grammar school insignia were in vogue when Henry Doelger, Francis McDonald, George McMurto, and their instructor from San Francisco enjoyed a camping adventure on the San Mateo County coast. Because of financial reverses, Doelger was soon to become a school dropout to help support his family. His strong early-life work ethic would lead him to success in the future.

Tracks of the ill-fated Ocean Shore Railroad are shown in the foreground at a popular stop along the train's scenic San Mateo County coastal route. The OSRR would cease to operate in 1920. When this 1912 photograph was taken, Doelger (second from left) and his friends could never have foreseen that the OSRR and Doelger's development of Westlake would bring his company and the line into a court confrontation in 1956 regarding a right-of-way dispute.

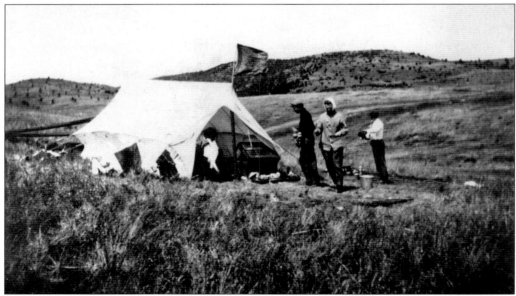

Camping out in the windy West was tall teenager Henry Doelger, wearing the black sweater, and his friends. The tent with an ad hoc flag flapping in the breeze might have been a distant forerunner to thousands of dwellings of a more substantial nature that Doelger would build near the coastlines of San Francisco and San Mateo Counties. In the 1950s, a much larger Westlake flag would catch north county winds.

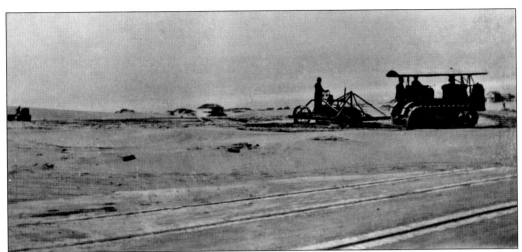

Grading for the first development of Doelger Built Homes in the Sunset started in 1925 with leveling of sand dunes between Judah and Kirkham Streets and between Thirty-ninth and Fortieth Avenues. Doelger was to construct 71 homes on this site. Streetcar tracks in the foreground were for the Judah line, which was not running at the time. Earlier-built homes, not by Doelger, may be seen on either side of the tractor-grader rig.

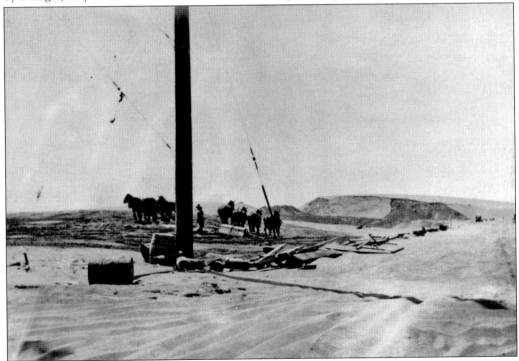

Teams of powerful horses plus human brawn were utilized when Henry Doelger continued grading San Francisco sand dunes to smooth the way for construction of homes. The large hill seen at the right in this 1926 photograph was at Thirty-ninth Avenue and Kirkham Street. Henry had followed the footsteps of his older brother, Frank, into land speculation, buying acres of sand dunes in the Sunset District that had been considered worthless by others.

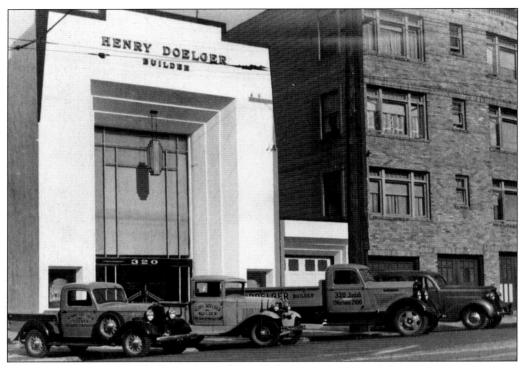

From an unpretentious "hole in the wall" with his name in raised lettering over a narrow entrance, Doelger and staff moved into this modernistic building at 320 Judah Street in 1932. Doelger once described his first office, located in a brick building "up the street at 8th Avenue and Judah," as "cozy but efficient." The office was partitioned to form a small entry.

Doelger's first block of Doelger Built Homes, constructed in 1926, was located at Thirty-ninth Avenue and Judah Street. Typical of the architecture is this "junior five." From the street-level walkway to the decorative touches just under the roof tiles, little embellishments added to the attractiveness of the residence. Bow-front windows, centered garages, and side entrance stairs were featured as well as illuminated house numbers.

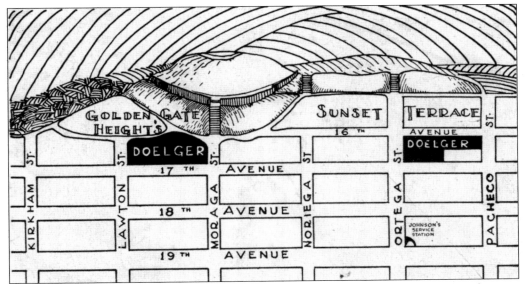

The onset of the Great Depression had forced a suspension of building, but by 1932, Doelger was developing Golden Gate Heights between Sixteenth and Seventeenth Avenues, Sunset Terrace between Ortega and Pacheco Streets, and the area he called "Doelger City" between Twenty-seventh and Thirty-ninth Avenues. "Location, environment, and grandeur of view" were among the advertised attributes of Doelger construction projects. This little map was used in a 1936 Doleger promotional brochure.

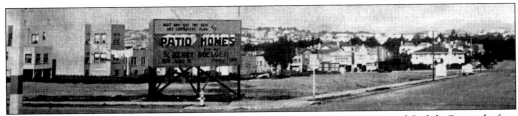

Patio homes were heralded on this billboard at Twenty-ninth Avenue and Judah Street before building in the area began in 1932. Four months later, 20 new Doelger Built Homes had been completed on the block shown.

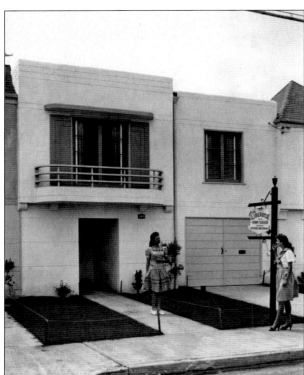

The Liberator was the dramatic name given to this Sunset District residence, decorated throughout by local furniture stores and opened for viewing as a model home. Names for Doelger exhibit houses included the Minuet, the Colonial, the Westchester, and the Forty-Niner.

Models of the human type were attired as typical apron-clad homemakers when they welcomed visitors to Doelger-built exhibition homes of the 1930s. Their tasks included pointing out features on display in the homes. On the coffee table, of course, was an issue of *House Beautiful* magazine.

Club-car breakfast nooks offered cozy seating, built-in china cabinets, and natural lighting from overhead skylight windows. Extra storage space was provided within benches that supported tufted cushions in the dining area. "Club car" referred to the shape of the nooks' seating, as found aboard popular streamlined passenger trains of the day.

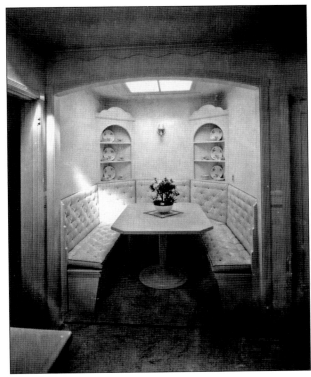

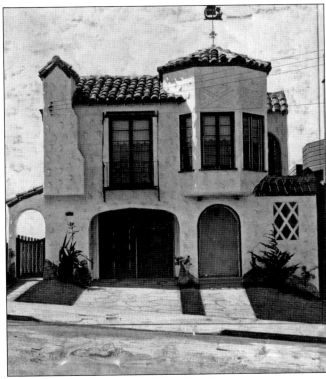

Casa Alhambra, with its highest point topped off by a Spanish-inspired wrought-iron ship under sail, drew crowds when it was used as a model home in October 1932. The building typified new Doelger homes available for purchase on Thirty-first Avenue.

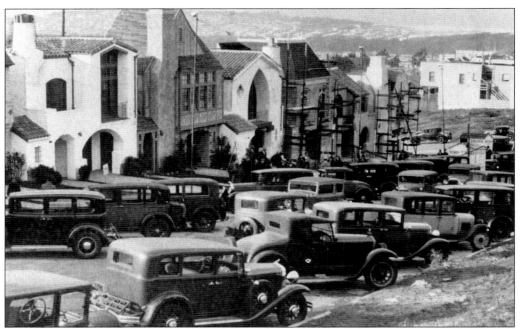

Average San Franciscans living on tight budgets were targets of Doelger's Sunset District rows of homes, and people flocked to tour them. Models included the Wiltshire at 1925 Seventeenth Avenue, built in 1933. Ad hoc lighting placed in front of the new buildings helped to display facade features and guide visitors to the houses, even in the fog.

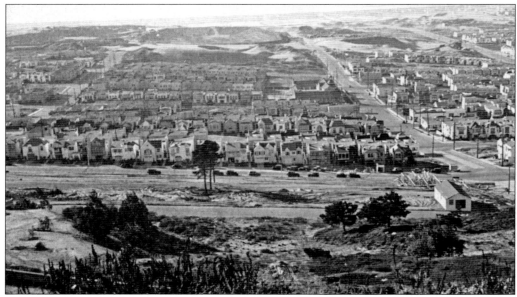

Looking west toward Daly City from the Sunset Terrace area was this 1937 view of property soon to be developed on Fifteenth Avenue between Ortega and Pacheco Streets. Already in place on the site is a Doelger construction shack and initial wood framing. Future homeowners were promised views of the ocean and beach, the Farallone Islands in the distance, and splendid golden sunsets.

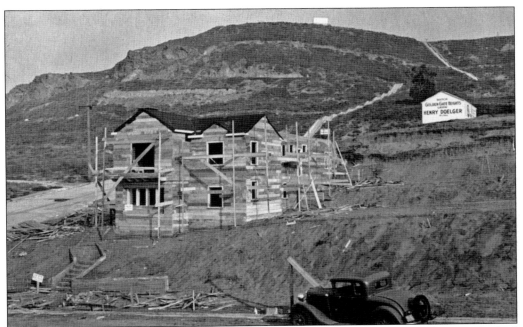

"Watch Golden Gate Heights Grow," invited the signage on the side of a Doelger supply shed high in open lands of San Francisco in 1938. These soon-to-be homes were being constructed on Fifteenth and Sixteenth Avenues, between Ortega and Pacheco Streets. They would not enjoy urban isolation for very long.

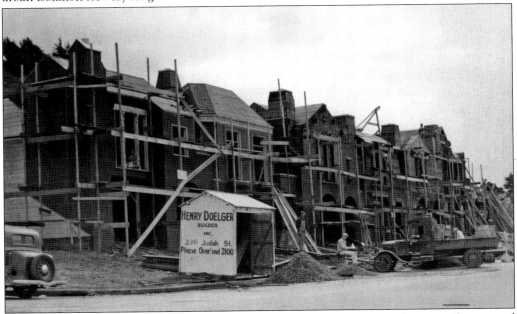

Reaching completion in 1938 were these homes on Eighteenth Avenue between Ortega and Pacheco Streets. From a modest beginning 12 years prior, Doelger construction teams had realized the remarkable achievement of completing an average of two homes per day. Features included patio entrances, fireplaces, and streamlined baths.

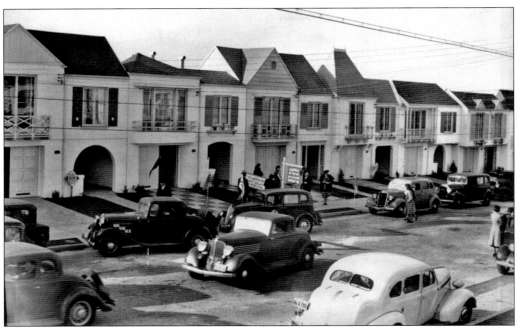

Model homes brought out lots of visitors and buyers in 1938 when the Clipper was open for view. This row of Doelger residences was completed on Thirty-third Avenue between Moraga and Noriega Streets. The dwellings were part of Doelger's boyhood dream to replace desolate sand dunes with modern homes.

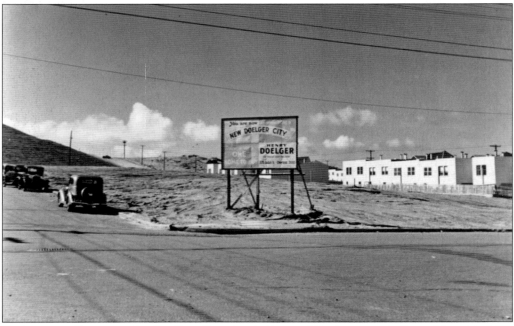

Predictions of progress in the San Francisco's Sunset District were indicated by this 1939 billboard heralding the location of the "New Doelger City" construction site. The sign was posted on Twenty-eighth Avenue between Noriega and Ortega Streets.

Inspired by the World's Fair on Treasure Island in San Francisco Bay was this charming view home at 1995 Fifteenth Avenue in Doelger's Golden Gate Heights. The residence drew largely on design and arrangement from a popular display of ideas for modern homes that attracted countless visitors at the 1939 Golden Gate International Exposition.

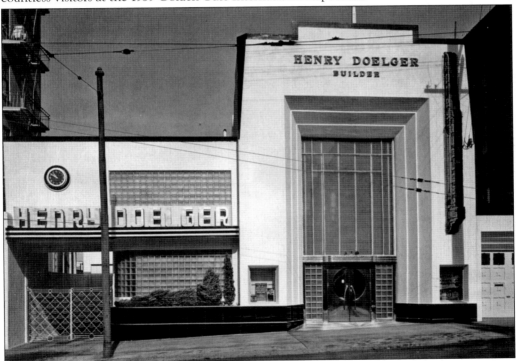

Larger lettering proclaiming the Doelger name was used in 1940 when a side addition was made to the builder's 1932 headquarters building. The office staff had expanded to include seven typists, bookkeepers, and stenographers. The sales force had grown from one to eight. The "streamlined" facade featured glass brick. Amenities included Doelger's private office, an architectural department, closing room, booking department, indirect lighting, and waiting rooms.

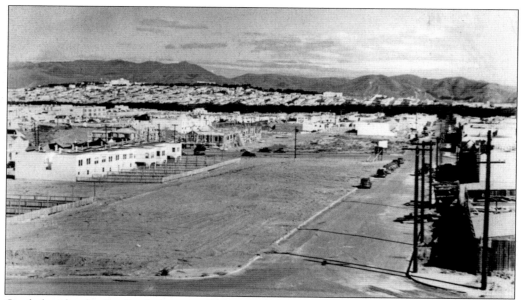

Graded and ready for development in 1940 was this expanse of land at Twenty-seventh Avenue and Ortega Street. Doelger "Homes of the Moment" signs can be seen on facing corners to the right, indicating that previously undulating sand dunes of the Sunset had been flattened and were soon to undergo home-building construction.

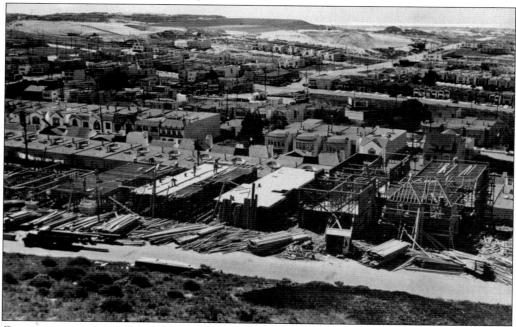

Construction continued in 1940 on Fifteenth Avenue between Noriega and Ortega Streets, although building starts were soon to be curtailed as World War II (1941–1945) would take its toll. Doelger's building expertise would be turned from the private sector to satisfying the housing needs of thousands of defense workers in San Francisco, South San Francisco, and Oakland as they assisted the war effort.

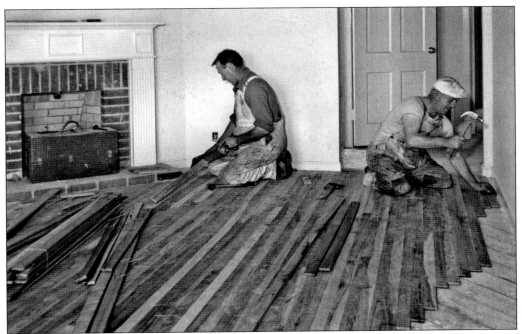

"How does one build a house?" asked an inquisitive acquaintance of Henry Doelger when he was deep into San Francisco home construction. "One nail at a time" was the reply. This 1945 photograph of "hardwood floors throughout," except for the bath and kitchen, attests to the one-nail policy.

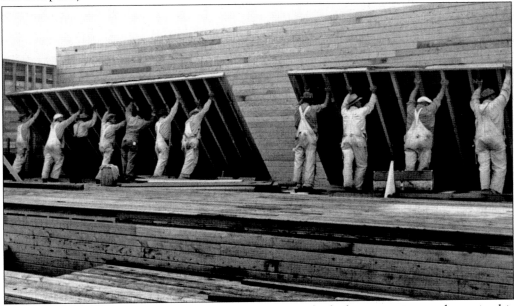

Labor-saving operations were stressed in the Doelger method of construction, as shown in this 1945 photograph of workers raising a blind wall. Walls were framed and siding nailed on while walls were laid flat. When walls for all homes in a particular block were complete, crews raised them into place. Temporary inside bracing was used until a follow-up crew joined the walls.

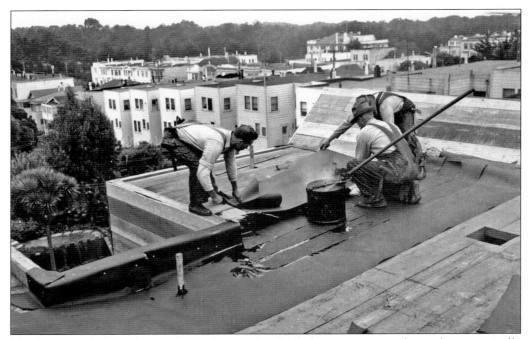

Membrane asphalt roofing and gravel, more familiarly known as tar and gravel, was typically placed on the flat roofs of Doelger's Sunset District row houses. Workmen in this 1945 photograph are applying the first layer of roofing prior to sloshing hot tar over the fabric.

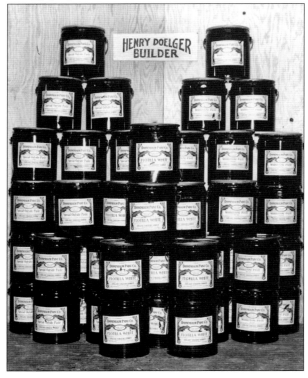

"White Cliffs of Doelger" became a popular name for Doelger Built Homes, thanks to the clever writing of *San Francisco Chronicle* columnist Herb Caen. As shown in this photograph, "White Cliffs" came in large cans of flotilla white from the Dannenbaum Paint Company on Vallejo Street in San Francisco. Made expressly for unstable climatic conditions of the bay region, the paint helped make Sunset District facades more permanent in color.

Two

WESTLAKE ON THE WAY

As thousands of service veterans and defense workers scrambled for housing in the Bay Area following World War II (1941–1945), Westlake was launched.

Only two years after V-J Day (August 15, 1945), housing entrepreneur Henry Doelger brought huge earthmovers to unincorporated San Mateo County to commence a monumental task of leveling sand dunes in preparation for Westlake housing and business enterprises. Fascinated with the dunes for many years, Doelger chose the mid-1940s to embark on his most ambitious construction project ever.

Some of the first residents of Westlake would be longtime business acquaintances, such as Hartley Appleton and his wife, Esther. The story endures that when Doelger was outlining plans to develop dunes near Daly City, the Appletons were among his listeners. Hearing that, some of his friends immediately told Doelger that they thought his idea was not the most sound.

"Who would ever want to live 'way out there'?" they questioned. Even before Doelger could respond, Esther Appleton took a $1 bill from her silk evening purse, handed the money to Doelger, and said, "Here's my down payment. I want a house on a corner." Doelger took the money. The Appletons' new home was built on an impressive corner near the entrance to a city park commemorating the historic 1859 Broderick-Terry duel. Being among the first families of Westlake was to carry a certain nebulous prestige over the years.

In the *San Francisco Call-Bulletin* of November 8, 1945, real estate columnist Harry Houle reported, "Surveys will be completed this month on an 800 acre tract in the northwest corner of San Mateo County, just over the San Francisco County line, and by the latter part of December Henry Doelger will start construction work on a complete community development." Houle was quoting Francis Newton, executive secretary of the Associated Home Builders of San Francisco. The development was to be "well under way by early Spring with many of the new homes occupied by that time." The reported building schedule was to be revised, but Westlake was on the way.

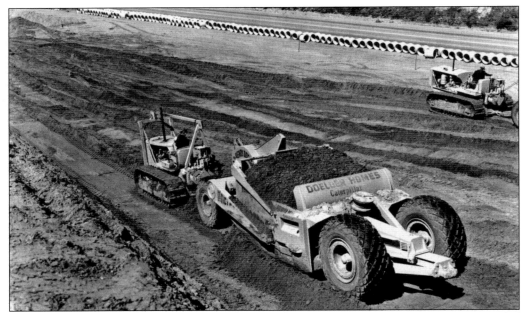

Preparations for construction of Westlake commenced in April 1947. Initial steps included moving approximately eight million yards of ground cover, of which about 13 percent was clay. Predictions called for 4,000 homes to be erected on 840 acres of open farmland. About 18 yards of loose sand was the load of this Doelger Homes Caterpillar No. 80 scraper being pulled by a diesel D7 tractor.

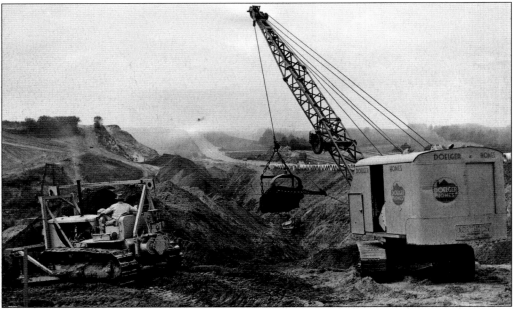

Alemany Boulevard, named to honor the first Roman Catholic archbishop of San Francisco and later to be renamed John Daly Boulevard, looms to the west in this August 1947 photograph of Doelger earthmoving activity. Trees to the right border Olympic Country Club terrain overlapping San Francisco and San Mateo Counties.

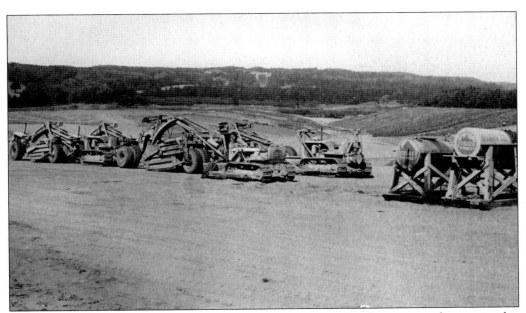

Olympic Country Club's elegant hospitality center oversees earthmoving endeavors in this September 1947 photograph of Westlake in the making. At the time, the Doelger Homes logo was still somewhat new to this unincorporated area near Daly City.

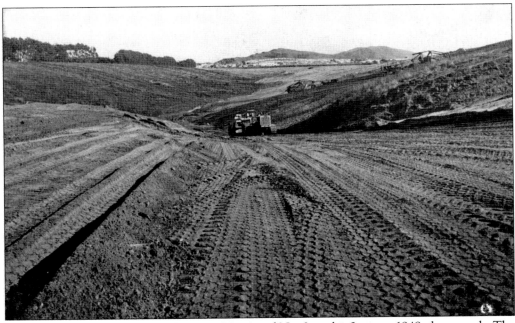

Grading commences for Westlake Units No. 1 and No. 2 in this January 1948 photograph. The area shown lies west of Junipero Serra Boulevard and north of Alemany Boulevard. Hillside District homes in Daly City can be seen to the east.

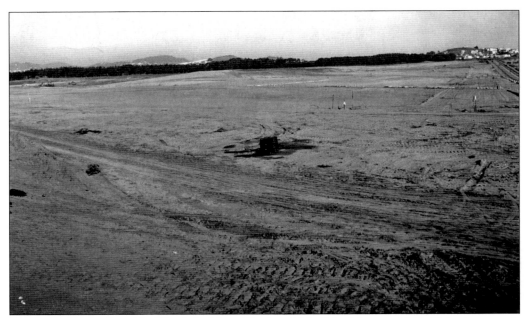

Grading was completed for Westlake Units No. 1 and No. 2 in February 1948. This photograph was taken from the north side of Alemany Boulevard looking east.

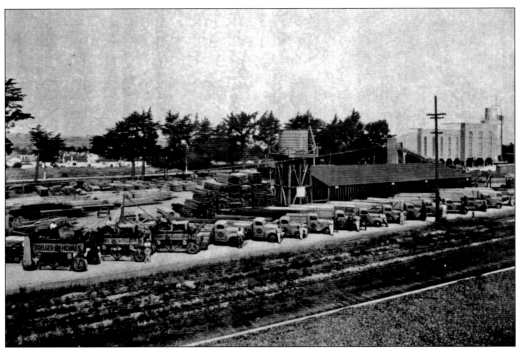

Men with lumber trucks exhibiting the Doelger logo, above, posed for this 1948 photograph of the Doelger construction yard near the intersection of Alemany and Junipero Serra Boulevards.

An on-site mill allowed speedier delivery of lumber to Westlake building locations. Here a load of redwood arrives to await placement in neat stacks around the yard and future use. Two years earlier, Doelger had purchased a lumber company north of Arcata, California. With it came 13,700 acres of redwood and fir forest property.

By 1947, Doelger was becoming noted as one of the largest lumber wholesalers in the United States, reportedly shipping 100,000 feet of finished lumber per day. The Westlake mill location would later become a restaurant site. To the south, homes of unincorporated Broadmoor Village highlight the hillside.

Vote *YES* on Annexation

HERE'S HOW THE ANNEXATION PROPOSITION APPEARS ON THE BALLOT

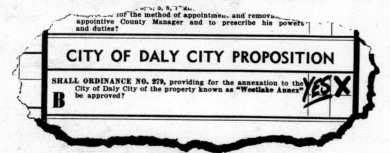

for the method of appointment and remova~
appointive County Manager and to prescribe his powers
and duties?

CITY OF DALY CITY PROPOSITION

B SHALL ORDINANCE NO. 279, providing for the annexation to the City of Daly City of the property known as "Westlake Annex" be approved? **YES X**

IT'S THE LAST PROPOSITION ON THE BALLOT

On November 2, 1948, voters of Daly City were asked to vote on annexation of Doelger's 432-acre Westlake subdivision just to the west of Junipero Serra Boulevard. The city council had already passed annexation ordinance No. 279. "Westlake Annex" promised to bring to Daly City 2,500 tax-paying homes generating more than $400,000 a year in revenue for the city; a free water reservoir site; a $50,000 community center; expanded school, park, and recreation facilities; better police, fire, and health protection services; and other amenities. (Courtesy of author.)

Let's Go! Help Our City Grow!

Daly City will vote November 2nd on the question of annexing the 432-acre Westlake subdivision off Junipero Serra boulevard.

Your mayor and city council have already endorsed and passed the annexation ordinance, which is now submitted to you for approval.

Here's what your "YES" vote on annexation means:

● An opportunity to enlarge our territorial boundaries almost half again over present size AT NO COST TO THE CITY.

● A complete new residential area, laid out and developed under strict city supervision and control to conform to modern community planning.

● 2,500 new detached suburban homes for our city, to be erected according to city building laws, and not by haphazard construction.

● Millions of dollars added to the city assessment rolls to lower the tax burden on present property owners.

● A water reservoir site, DONATED FREE OF CHARGE TO THE CITY, to insure an unlimited pure water supply. (Our water situation is now critical.)

● Thousands of new customers for our water department to make possible lower water rates.

● More business for our merchants and trades people.

● Expanded school, park and recreational facilities for our people.

● Better police, fire and health protection.

● All streets, curbs and gutters, sewers, electroliers, water system, hydrants and fire alarm system installed according to city specifications AT NO COST TO THE CITY.

● Increased city census, giving Daly City greater influence and recognition, and a larger share of county and state financial grants and benefits, which are based on population.

● Lower insurance rates.

MAKE DALY CITY BOTH A BIGGER AND BETTER PLACE IN WHICH TO WORK AND LIVE.

YES FOR ANNEXATION Citizens Committee
A. L. SUNDSTROM A. J. BODIEN
General Chairman Co-Chairman

8

Not the least attractive of the reasons for annexation was "increased citizen census, giving Daly City greater influence and recognition, and a larger share of county and state financial grants and benefits, which are based on population." As shown by these political promotion pieces, the area of Daly City would almost double with Westlake annexation. The proposition was passed. (Courtesy of author.)

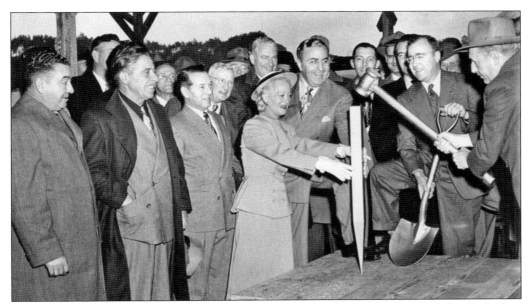

While Thelma (Mrs. Henry) Doelger held the ceremonial spike, ground was symbolically broken and dedicated in March 3, 1949, for construction of Westlake Town and Country Shopping Center. Onlookers include Elmer Kennedy, Milton Morris, Arthur Bodien, Thelma Doelger, Henry Doelger, John Doelger, Frank Fullam, Bill Adams, George Taylor, Daly City mayor Paul Green (with gold-painted spade), and D. C. McGinnis (applying the gold-painted hammer).

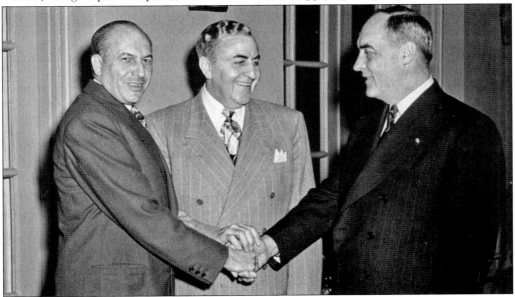

The bankers and the builder display mutual trust in this March 1949 photograph of D. C. McGinness (left), director of the Federal Housing Administration (FHA), with Westlake developer Henry Doelger (center) and Carl Wente (right), Bank of America president. Doelger credit via the Bank of America was reported to have been near $100 million following the 1926 real estate crash. FHA programs helped to finance many Westlake homes purchased for returning World War II veterans and their families.

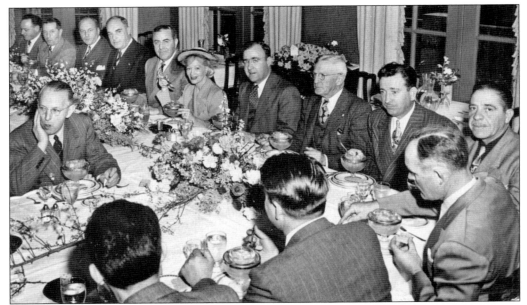

Floral tributes from well-wishers decorated the Olympic Club as Westlake dedication participants enjoyed a festive banquet after ground breaking and handshakes. The head table included, from left to right, Fred Bargoni, Milton Morris, D. C. McGinnis, Carl Wente, Henry Doelger, Thelma Doelger, Paul Green, Art Bodien, Elmer Kennedy, and Lawrence Vannucci.

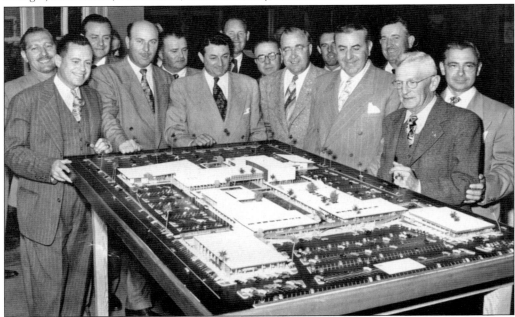

Westlake Town and Country Shopping Center in miniature was ogled as part of dedication festivities in March 1949 at the Olympic Club. Among those shown with entrepreneur Doelger (fourth from right) were Daly City councilman Anthony Gaggero (sixth from left) and Daly City mayor Paul Green. Second from right is Arthur Bodien, who had been cochairman of the Citizens Committee for annexation of Westlake to Daly City.

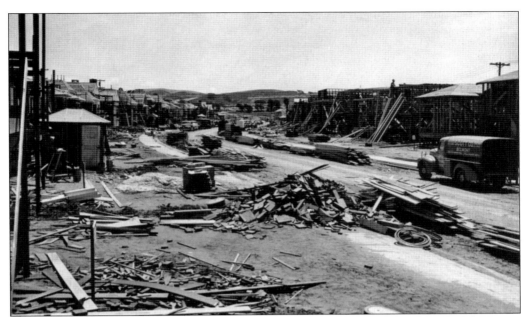

Heaps of rubble, perhaps, but this seemingly unsightly June 1949 street scene in Westlake meant new and anxiously awaited homes were on the way. Job foremen allowed local youngsters to take away bits of lumber for at-home carpentry projects and hobbies. Kid-pulled wagons were welcome; adult vehicles were not.

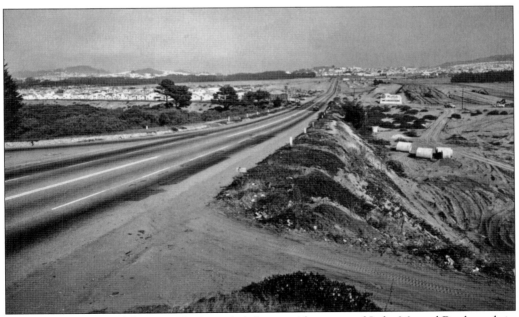

Construction in Westlake Unit No. 1 nestled close to Alemany and Lake Merced Boulevards in this October 1949 photograph. The signboard to the right indicates a shopping center was soon to be constructed in Westlake. Utility vehicles and large conduit pipes wait on newly leveled land. Note the absence of vehicular traffic on Alemany Boulevard.

Alemany Boulevard alterations of the sandy sort were soon to be accomplished as earthmovers continued to level the landscape in this October 1949 photograph documenting the onset of construction of Westlake Town and Country Shopping Center. Alemany was to be renamed to honor Daly City's turn-of-the-20th-century benefactor, John Daly. Years later, a brief movement was launched to name the wide thoroughfare in honor of Henry Doelger. That idea failed.

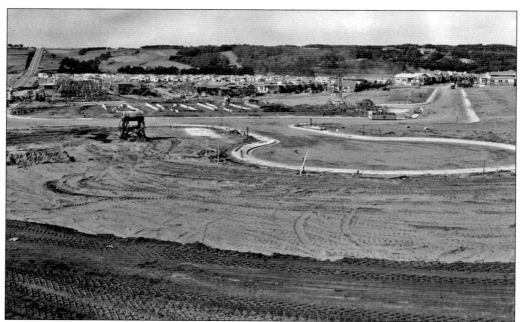

Westlake Unit No. 1 expanded east along Alemany Boulevard, rising to the left, between Lake Merced and Junipero Serra Boulevards as this March 1950 photograph was taken. Many stages of home construction are visible, from foundations to framing and finished dwellings. Olympic Club's handsome clubhouse peeks through the trees to the right.

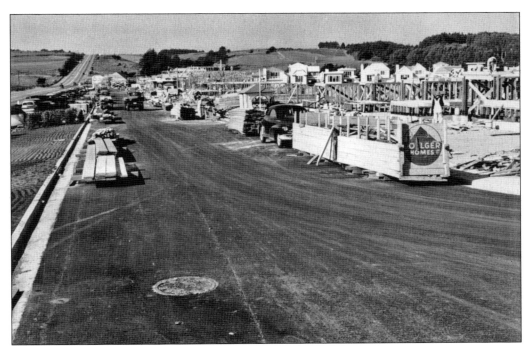

The distinctive Doelger Homes logo was highly visible in this April 1950 photograph as Westlake Unit No. 1 neared completion. The tree-filled area in the background is part of the Olympic Club's manicured golf course.

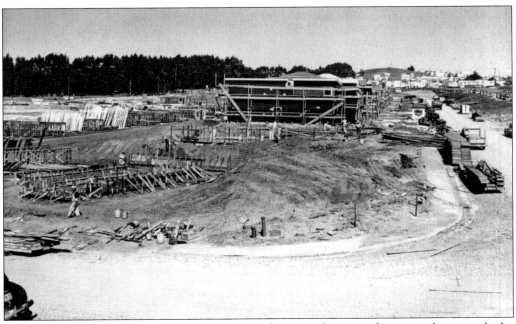

With the knoll of Bepler Hill to the east, Westlake Unit No. 1 speeds to completion with the help of prefabricated materials neatly stacked and ready for placement. Lake Merced Golf and Country Club trees are shown to the left, extending toward Junipero Serra Boulevard.

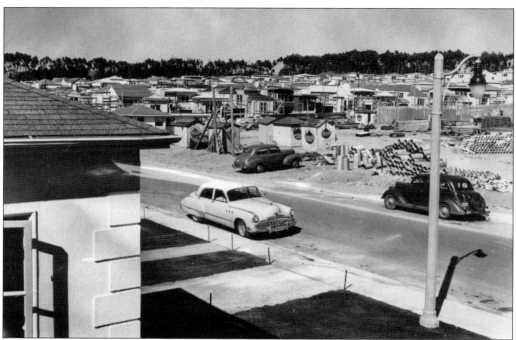

Construction shacks and pipes abutted new houses in April 1950 as Westlake Unit No. 1 continued to grow. As homes were being completed, topsoil was placed for landscaping and seeds sown for entranceway rectangles of grass. Sod was not yet in vogue.

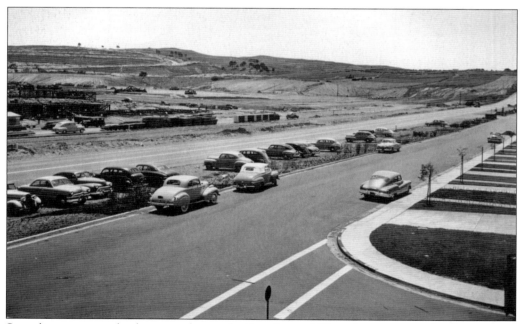

Sprawling over gentle slopes to the south, Broadmoor Village homes were already occupied in June 1950 as Westlake began to welcome residents to its newly completed houses. Graded property at the center would become the Westlake Town and Country Shopping Center.

Polished shoes and suits with wide lapels were the garb of the day in October 1950 when photo-op ceremonies launched construction of Westlake Town and Country Food Center. The supermarket would be the first business to open its doors in Westlake. Shown from left to right are Paul Green, mayor of Daly City, with gilded mallet; Carl Vedell, construction superintendent, wearing hat; William Sutherland, chief of police; Vincent J. Nevolo, market lessee, holding the symbolic spike; and Henry Doelger, developer.

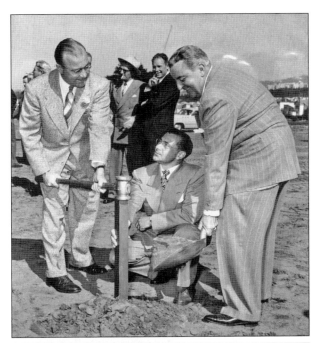

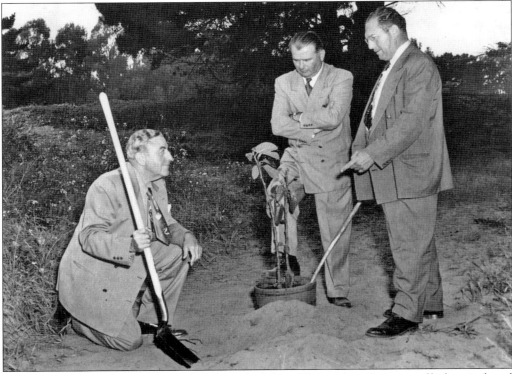

While the potted fig tree waits, Fred Bertetta (right) and Bernardino Poncetta offer horticultural advice to Henry Doelger. The fig was planted in Westlake Park. History does not record any edible figs plucked from the mature tree.

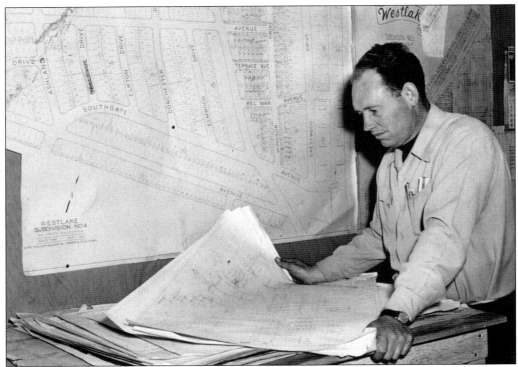

Senior construction superintendent Carl Vedell's desk is laden with plans in this April 1951 photograph. On the wall beside him is a street plan for Westlake Unit No. 4. Marked-out Bellevue Drive between Clifton and Ashland Drives was later named Lakewood Drive. The name had duplicated an avenue in the Crocker Tract of Daly City dating from the 1920s.

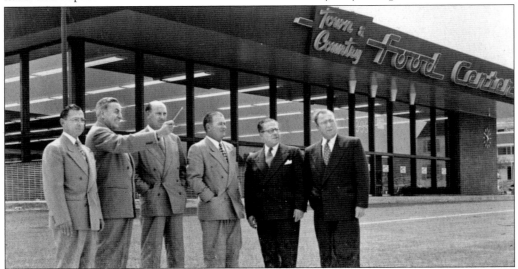

Opening day for the Westlake Town and Country Food Center was photographically documented with this April 20, 1951, lineup of well-suited gentlemen. From left to right are market owner Vincent J. Nevolo, Henry Doelger, James Kennedy, Bernardino Poncetta, Emile Rafetto, and Paul Green, mayor of Daly City. Nevolo was the first merchant to open his doors in Westlake.

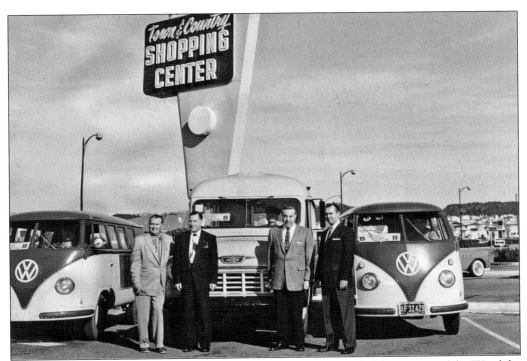

Transportation via Volkswagon and Chevrolet shuttles were provided for patrons of the Westlake Town and Country Shopping Center during the 1950s. Maintained by the Doelger Corporation, the vehicles operated between the Daly City county line on Mission Street and the center. The fare, posted prominently, was 15¢ each way.

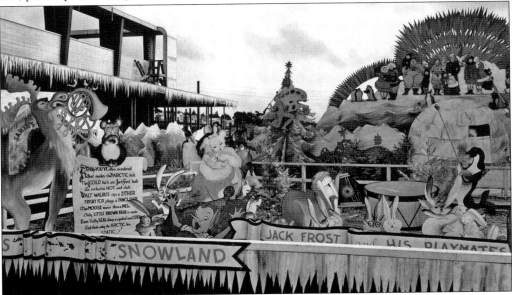

In the winter of 1951, Westlake's Snowland debuted in a portion of the shopping center's open space. Reportedly one of the largest Christmas displays in America, the spectacular representation of Arctic habitat welcomed over 150,000 visitors between December 15 and New Year's Day.

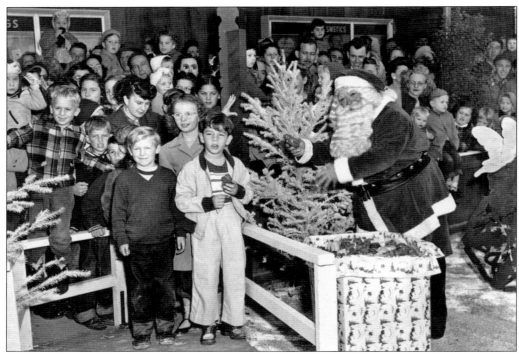

Snowland's official host was Santa himself, shown here distributing small plastic piggy banks of various colors. His annual arrival in Westlake was a happy tradition for many years.

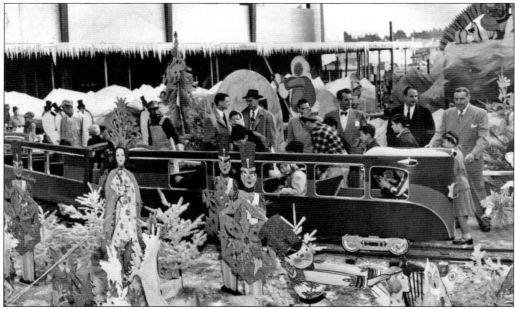

Chugging into Westlake for the last two weeks of 1951 and generating interest from adults and children alike was the *City of Westlake*, offering "free rides for all" and photographic opportunities. During its extended layover, more than 35,000 passengers boarded the train for a mini-excursion around the shopping center parking area.

Three

"DOELGER'S GREATEST ACHIEVEMENT"

In October 1952, Henry Doelger's Westlake was hailed in the *San Francisco News* as his "Greatest Achievement." A six-column photograph of Westlake dominated a full-page spread in the newspaper, flanked by columns of print on both sides. The photograph was a comprehensive aerial view that included the shopping center, construction of a housing unit near Lake Merced Boulevard, Westlake Elementary School, a 10-acre playground in construction, and various nearby recreation areas.

The feature noted, "Construction began at Westlake little more than three years ago. It now boasts more than 2000 completed and occupied homes, housing more than 7500 persons. . . . There is no end in sight for this progress, at least not until Doelger and his associates complete development of their entire 1200 acres."

According to the *News*, "500 more homes are under construction and work will begin on construction of 2500 more homes in a new tract in approximately eight months. The two and three-bedroom homes, built from sixteen different floor plans but basically alike inside, are distinguished by their exteriors. Doelger utilizes 320 varied exteriors in Westlake, no two are alike in the same block. Also under construction are 128 new Country Club apartment units which will bring the total number to 750."

The story concluded, "When Doelger Homes completely develops Westlake, there will be more than 8000 homes in this district, housing an estimated 32,000 persons."

While home construction continued, much attention was given to expansion of the Westlake Town and Country Shopping Center, which had opened about a year and a half earlier. It was considered to be the Bay Area's most complete one-stop shopping center, and its 3,000-car parking area was thought to be the nation's largest.

Westlake's mall was to become a management- and merchant-sponsored community gathering place as well as a mecca for shoppers and strollers, with free entertainment ranging from fashion shows and celebrity appearances to ribbon-cuttings for new businesses, plus weekly prize drawings and abundant giveaways.

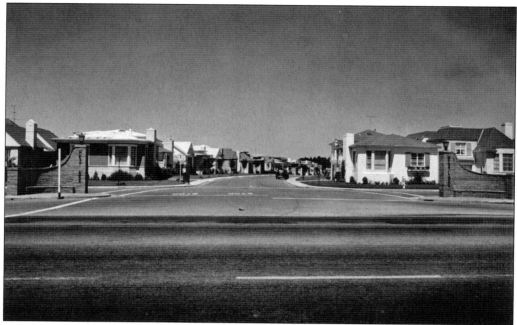

Twin brick portals identify the entrance to a gently curving Westlake thoroughfare, one of the first completed as Doelger's "city within a city" took shape in the 1950s. Prospective purchasers were invited to "enjoy all the comforts of suburban living just twenty minutes from downtown San Francisco by car."

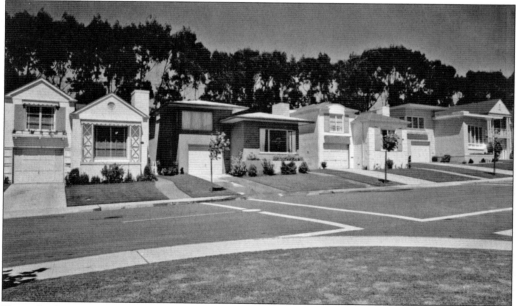

Typical of Doelger's "no two frontages alike in any one block" policy regarding the facades of Westlake homes is this row of split-level residences. Westlake building plans included 320 different frontages, making it uncommon to find two nearby homes that appear the same from the outside.

Two- and three-bedroom homes, built on the split-level design, were featured throughout Westlake. Elevated bedrooms were reached by a stairway located between the living room and dining room. Fireplaces were primarily decorative. Entrance doors faced the interior stairway. "The flow of rooms in a Doelger home is emphasized here," reported *Practical Builder* magazine.

Although Doelger homes were built from 16 different floor plans, they were basically alike inside. Each home had a two-car garage, full-tile bathrooms, and kitchens with electric garbage disposal units. Available at the Town and Country appliance store were Westinghouse and Universal refrigerators for approximately $249 and Tappan gas or electric ranges for $369. A model house, opened in 1950, sold in half an hour for $9,000.

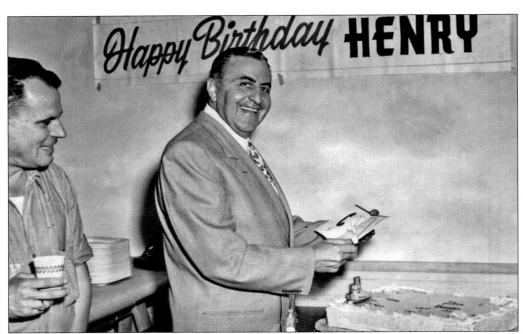

Looking as pleased in this June 1952 photograph as any person with an enviable and remarkable record of achievement and financial success, entrepreneur Henry Doelger celebrates another milestone in his life. He had reached the age of 56.

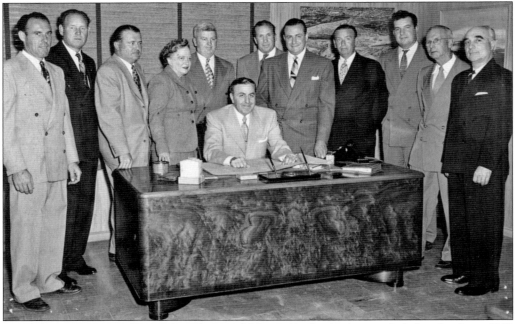

Westlake corporate staffers gathered around Henry Doelger's elegant desk for this June 1952 photograph. Shown from left to right are Dale Williams; Carl Vedell; Bernardino Poncetta, production vice president; Alpha Porter, secretary-treasurer; Irwin Smith; Henry Doelger (seated); Harry Porter; John Doelger; Bill Hickey; Larry Neiry; J. Jacobsen, and U. R. "Jack" Kendree.

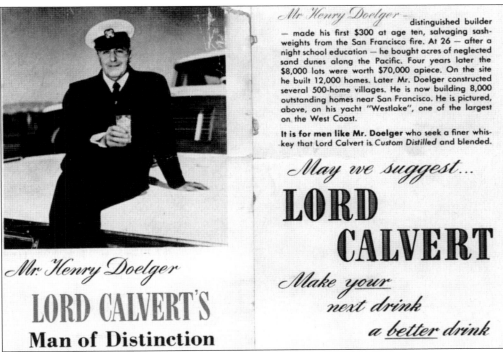

"Man of Distinction" was the accolade given to Henry Doelger in September 1952 as Lord Calvert custom-distilled whiskey launched a full-blown promotional campaign for outstanding business achievers. With the title came a bit of vicarious fame for Westlake and Daly City, as this jaunty nautical image of Doelger was used in advertisements across the country—on billboards, on specially labeled bottles of the product, and on table tents displayed in places selling potables.

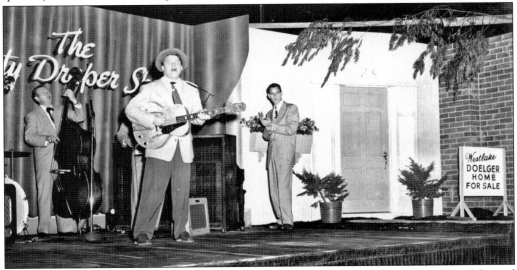

Rusty Draper, one of California's "fastest rising entertainers," brought his talents to Westlake and attracted hundreds of fans anxious to see his free mid-week concert in October 1952. Draper's mid-mall performance was televised in the Bay Area as part of ceremonies marking the opening of Westlake Town and Country Shopping Center's unit four.

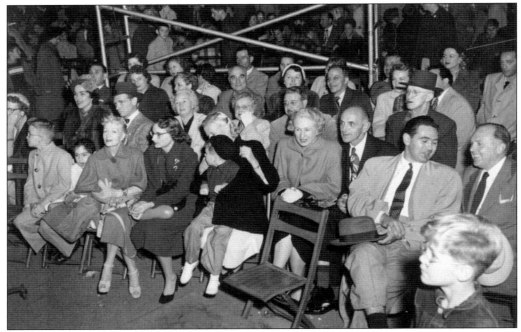

Standing room and 1,000 free seats were available on a first-come basis when Rusty Draper brought his guitar, songs, and *Rusty Draper Show* to Westlake in October 1952. Shown in the front row are, from left to right, Michael Doelger, Susan Doelger, Thelma Doelger, Joyce Doelger, Jane Doelger, Johnny Doelger, and Hartford Rapp Jr.

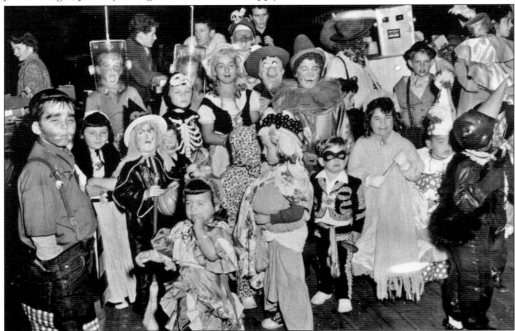

Robots and tramps mingled with skeletons and witches at the Westlake mall to take part in the shopping center's 1952 Halloween costume parade and party.

Halloween revelers lined up for bags of candy and tubs of ice cream when Westlake merchants hosted hundreds of costumed children and adults on an October evening in 1952. Wrapped surprises were awarded to lucky ticket holders.

Decked out in their Westlake Junior League baseball team uniforms and logo caps are local young athletes with their corporate sponsor, Henry Doelger, in this March 1953 photograph.

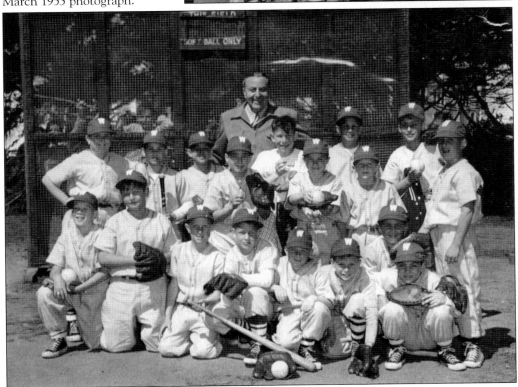

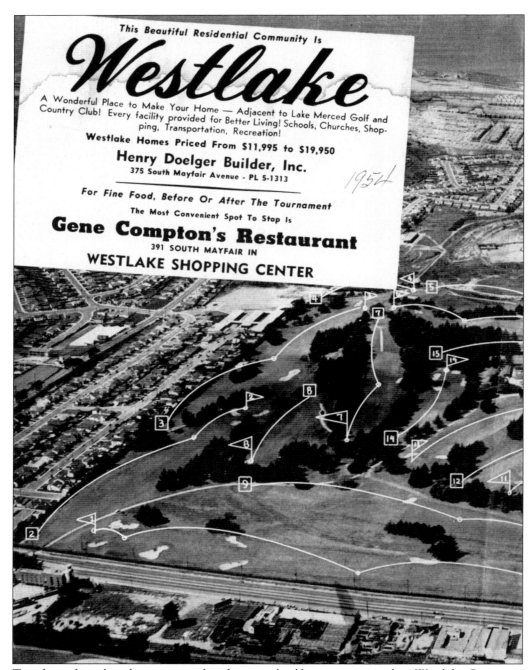

Top players have long been attracted to the several golf courses surrounding Westlake. Proximity to Lake Merced Golf and Country Club was promoted in this 1954 tournament program page. The Pacific Ocean is in the west at the top of the illustration. Junipero Serra Boulevard at the bottom is empty of cars. Even in sometimes unpredictable fog, champions have accepted the challenges of rivals and competed with satisfaction on local greens.

50

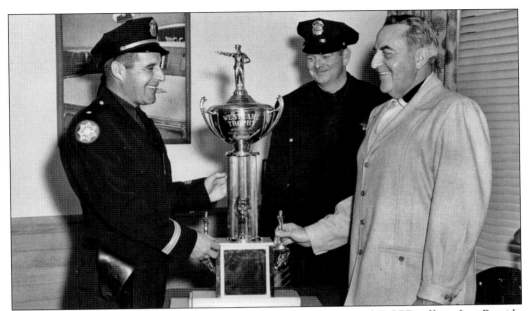

Roland Petrocchi, chief of the Daly City Police Department, and DCPD officer Les Bastido (center) met at Henry Doelger's office in January 1954 to receive the Westlake Trophy, an impressive award recognizing the force's intra-department shooting competitions. Atop the trophy is a figure taking aim at, perhaps, the chief's hat.

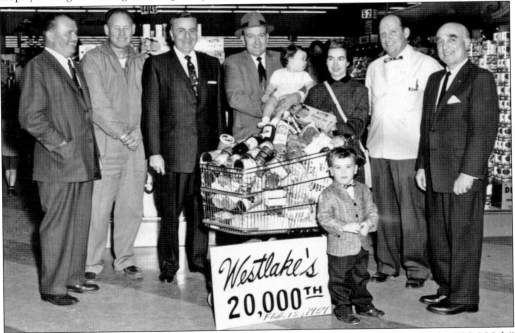

Proof that Westlake was growing, and growing, is this line-up of happy faces as the "20,000th" receives a sizeable load of complimentary groceries. The name of the winning family has been lost, but among those congratulating the winners in this Lincoln's birthday photograph in 1954 was Henry Doelger (third from left).

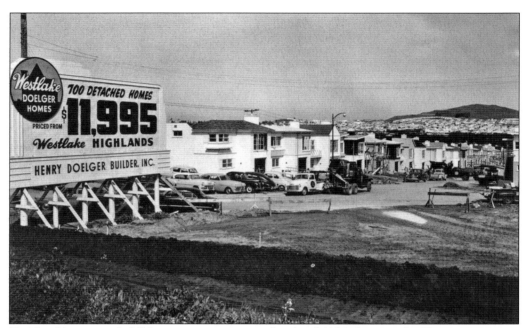

Two-level homes with full basements are seen in this April 1954 photograph of houses in various stages of development in Westlake Highlands. Frontages adhere to Doelger's long-standing policy of unduplicated facades along rows of neighboring houses. In the distance are homes near Daly City's Hillside neighborhood.

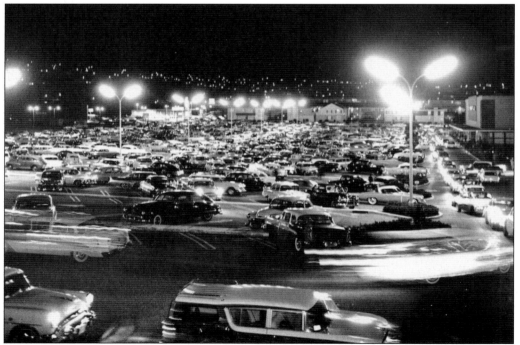

Lights were bright and automobiles cruised to locate parking spots in Westlake's south parking area when this spectacular nighttime photograph was taken.

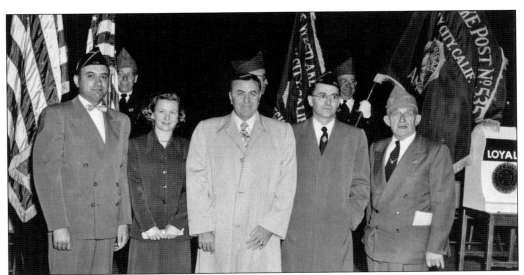

Officers of Westlake Post No. 535 of the American Legion and local dignitaries were present on May 14, 1956, for the presentation and dedication of American and organizational flags. Shown from left to right are Hal Blumenthal, commander of the post; Mrs. Cancilla, commander of the post auxiliary; Henry Doelger, donor of the flags; Judge Lewis Demattais; and Joe Madden, dedication officer.

Pretty little princesses perched on a Daly City Fire Department vehicle when a crown of flowers was placed by a member of the Boy Scouts of America in this May 1954 photograph taken at Westlake mall. One of these young ladies might have been a future Miss California.

The 1954 opening of a Bank of America branch in Westlake Court brought officials of the world's largest bank to Daly City. Shown from left to right are Romey Moretti, Bank of America senior vice president; Carl Wente, Bank of America president; Henry Doelger; D. J. Franco, manager of the Westlake Bank of America branch, and R. J. Barbieri, Bank of America vice president.

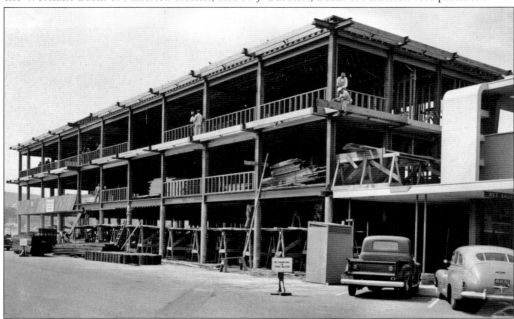

Medics were on the way as the Westlake Medical and Dental Building was being built in May 1954 on Park Plaza Drive. The multilevel facility would include a corner pharmacy and ground-level coffee shop. Elevators lifted patients and patrons to upper-level offices.

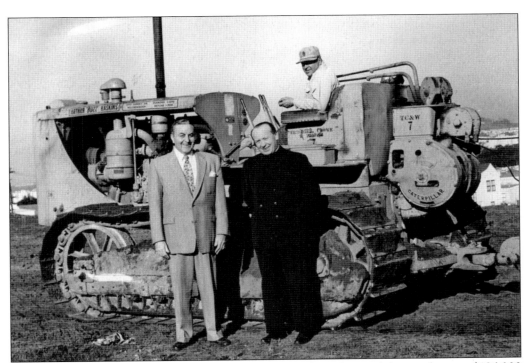

Ground breaking for Our Lady of Mercy parochial school on Elmwood Avenue began a $186,000 construction project in January 1955. Shown is Henry Doelger with Fr. Richard W. Power, pastor of OLM Church, while a patient Cat driver awaits instructions to begin work. The school was to be ready for 400 children the following September.

Utility vehicles of many kinds and capabilities were part of the Doelger construction fleet. In this January 1955 photograph, driver Roland Jeppesen poses with "the boss." The building entrepreneur's casual jacket evidences his fondness for appropriate attire.

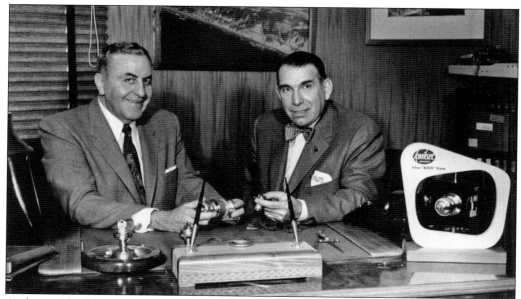

Architect Lloyd Gartner and Henry Doelger discuss the latest in Kwikset Locks in this February 1955 photograph. Gartner described his role as chief designer of all units of the Westlake Town and Country Shopping Center as his "most interesting work to date." While Doelger homes were different on the outside but similar on the inside, Gartner reversed the procedure to make each business facility appear distinctive inside but with similar frontages.

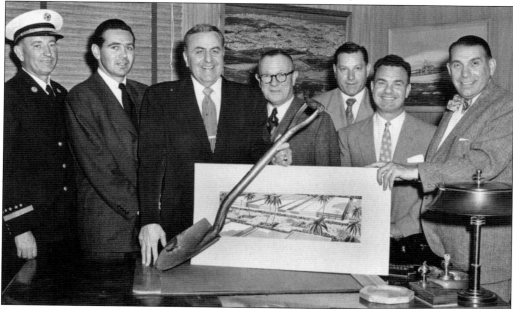

Backing an artist's rendering of proposed stores and landscaping of Westlake mall were participants at ground-breaking ceremonies in April 1955. Shown from left to right are Daly City Fire Department chief Elmer Kennedy, Hartford Rapp Jr., Henry Doelger, George Roberts, Daly City councilman Del Wilson, Daly City mayor Joseph Verducci, and mall architect Lloyd Gartner.

Four

WHAT'S IN A NAME?

While Henry Doelger was developing Westlake, Abraham Levitt and his sons, William and Alfred, were developing Levittowns in New York, New Jersey, Puerto Rico, and Pennsylvania. Coincidentally, both Doelger and Levitt had seized the opportunity of satisfying needs for post–World War II housing. Their projects were somewhat parallel.

The most famous of the four Levittowns, in New York, utilized potato-growing land formerly called Island Trees. In 1945, Doelger acquired sand dunes and farmland that had also been yielding root crops. It was designated as unincorporated San Mateo County.

There was little doubt that the Levitt name would be immortalized in their construction projects. The name of Doelger, however, was another matter. There has never been official designation of a Doelgertown or a Doelgerville. San Francisco's Sunset District had, at times, been dubbed "Doelger City," "New Doelger City," and "The White Cliffs of Doelger" but not officially.

In the 1970s, Fr. Joseph A. Gordon, assigned to Our Lady of Mercy parish, gleaned a bit of insight on the naming of Westlake's only Roman Catholic church. According to history-buff Gordon, it was in 1953 when John J. Mitty, then the Roman Catholic archbishop of San Francisco, decided to establish a parish in Westlake. He called Fr. Richard W. Power to be the founding pastor. Mitty intended to name the parish St. Henry.

Father Power panicked. "Don't do it, Archbishop," he urged. "For my sake, for the sake of the new parish, and for your sake. It will forever be seen as crass patronizing of Henry Doelger. Neither you nor I will ever live it down." Mitty had second thoughts. He accepted Father Power's suggestion to name the parish denoting proximity to nearby Lake Merced.

The naming of Westlake was mysteriously and perhaps whimsically achieved, allowing Doelger conversational gambits over the years. The area is not located west of Lake Merced or any other lake. With a twinkle, Doelger enjoyed explaining that the development refers not to a geographical location but to "My cousin, Mae." The Hollywood actress Mae West, reportedly, was a grandchild of Joseph Doelger, credited with establishing beer breweries in New York. Whether the famed flirtatious femme fatale movie star was truly a relative of Henry Doelger is an unsolved mystery.

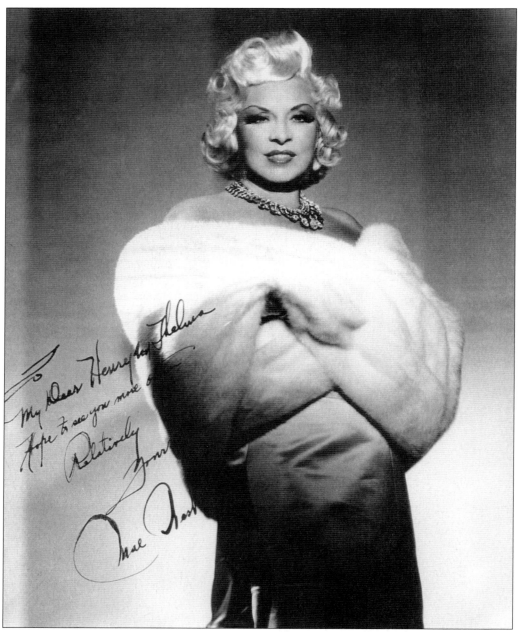

Hollywood movie queen Mae West coyly kept people guessing about familial ties to Westlake's developer. In a 1955 column, San Francisco's famed newspaper columnist Herb Caen wrote: "Homebuilder Henry Doelger is having a ball around town with Mae West who, he insists, is a long-lost cousin. Her maiden name, he says, was Doelger, a point Miss West refuses to confirm or deny. Following dinner and an inspection tour of Westlake construction, Mae cooed, 'I can see that you're well-built, too!' " Her autograph on this picture avers "relatively yours."

The Easter bunny visited Westlake mall to distribute 5,000 free foil-wrapped chocolate Easter eggs on a pre-holiday Saturday in April 1955. Seasonal attractions such as this representational creature always attracted crowds of youngsters.

J. C. Penney department store was a structure in steel when this photograph was taken in August 1955. Penney's would officially open in the spring of 1956, along with 12 other new Westlake stores. The store would become Westlake's largest, with 51,000 square feet of space and nearby parking for 2,500 automobiles. Broadmoor Village may be seen to the south.

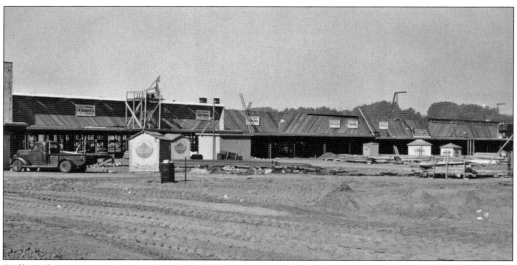

Still under construction in October 1955 were courtside businesses, including F. W. Woolworth variety store, Karl's Shoes, and Thom McAn Shoes. On completion, Westlake Shopping Center would embrace 65 stores.

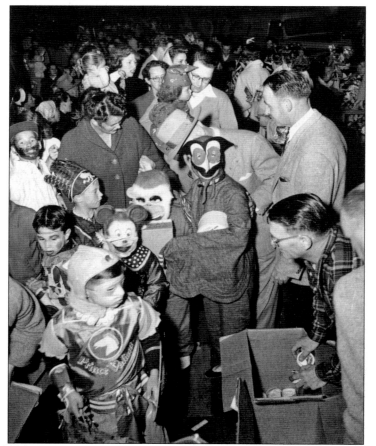

Hundreds of costumed contenders rubbed elbows as they lined up to receive treats and awaited announcement of prize winners at Westlake's 1955 annual Halloween party. Events in the mall were always free and open to all.

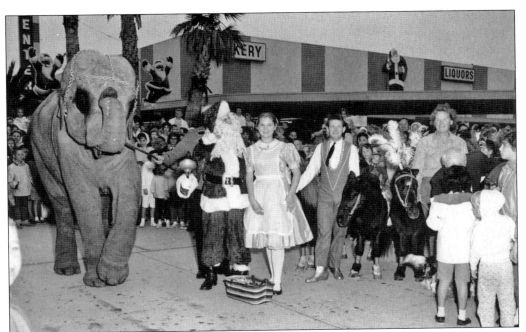

Jumbo the Elephant, miniature horses, and Alice in Wonderland were among seasonal surprises brought to Westlake for the 1955 visit of Santa Claus. Santa images were suspended from palm trees and stood guard atop store overhangs.

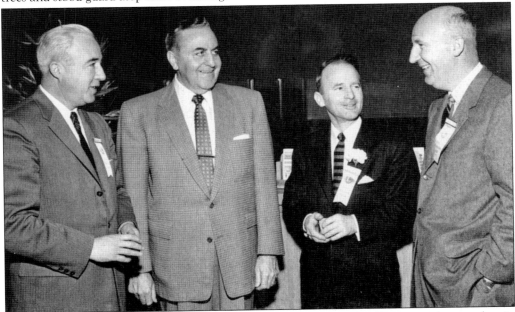

Belford Brown (right) was later to become general manager of San Francisco Airport, but in this photograph he was vice president of First Western Bank. He is shown as the institution opened a Westlake branch in March 1956. From left to right are Charles Monahan, First Western Bank vice president; entrepreneur Henry Doelger; and Ted Harris, First Western Bank branch manager.

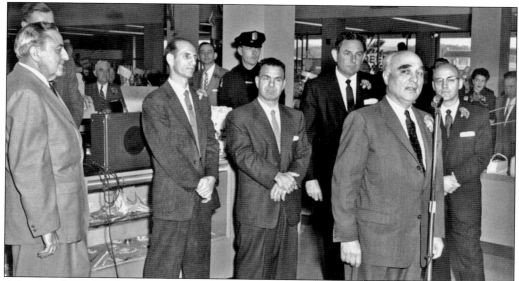

A landmark weekend in Westlake was observed as 12 new businesses sponsored grand opening festivities March 23–25, 1956. Civic and community leaders helping welcome J. C. Penney's department store included U. R. "Jack" Kendree (at microphone), Westlake Shopping Center general manager; and Daly City mayor Joe Verducci (third from left). Don Davis (far right), would manage the new store. Other stores opened that day were Woolworth, Grant, Sears, Franklin Fashion, Bank of America, Karl's, First Western Bank, Leed's, Jay Vee, Arthur's, and Arcade Shops.

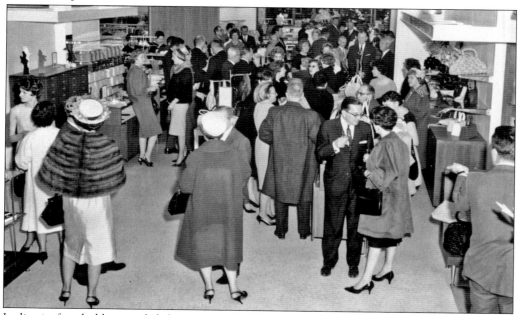

Ladies in fur chubbies, stylish hats, and spiked heels were among the revelers enjoying edibles and potables when J. C. Penney hosted a gala reception honoring the opening of its Westlake branch. Two mink stoles were among a galaxy of prizes to be awarded to lucky ticket holders during Westlake Shopping Center's expansion celebration.

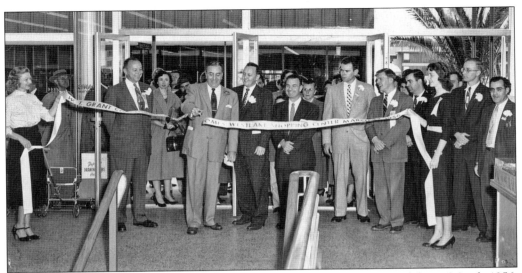

It was a busy day for ribbon cutters as a dozen new stores opened in Westlake in March 1956. Henry Doelger cuts a ceremonial streamer for the opening of W. T. Grant Company in this photograph, while employees, erstwhile shoppers, and officials watch. Also shown are store manager ? Johnson and Daly City mayor Joe Verducci (sixth from left).

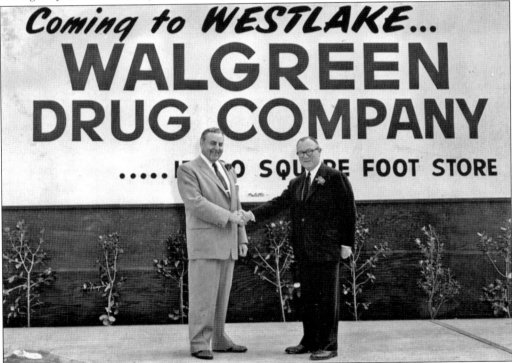

Slated to open in the near future was a branch of Walgreen's Drug Company as signified in this March 1956 photograph. Henry Doelger was on hand to congratulate George S. Roberts, San Francisco realtor, on completing arrangements for bringing the mega-store to Daly City. Roberts's firm had recently become leasing agents for Westlake.

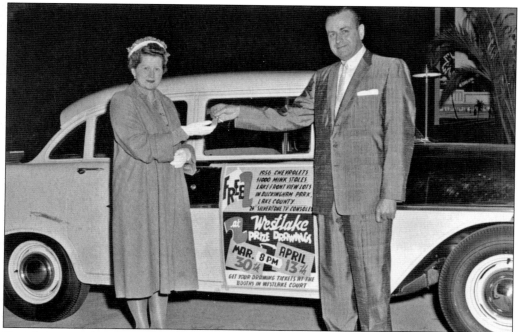

Grand opening festivities for Westlake Shopping Center included two drawings for $10,000 in prizes. Tickets were distributed from two booths in the center, and winners did not have to be present at drawings. Winner of a 1956 Chevrolet in the March 8 drawing was Norma Albrechtsen of Sharp Park, shown with John Doelger.

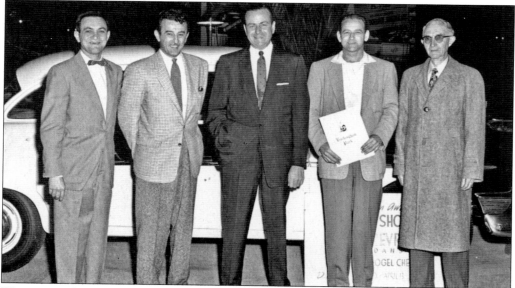

Winners in the second of Westlake's grand opening drawings were selected on April 13 and received their prizes from John Doelger. Shown from left to right are T. R. Giannini Jr., whose lucky ticket brought him a Silvertone television set; O. W. Hellwig, winner of a 1956 Chevrolet sedan; John Doelger; Barney Mullen, winner of a lakefront lot in Buckingham Park, Lake County; and James Farrell, recipient of a $1,000 mink stole.

Leed's shoe store was among those welcomed to Westlake in March 1956. In this April photograph, Daly City mayor Joseph Verducci (right) checks drawing entries with a Leed's representative. Also opened in March were Arthur's Store for Men, Sears, Karl's shoes, Bank of America, Thom McAn shoes, Franklin Fashions, and F. W. Woolworth.

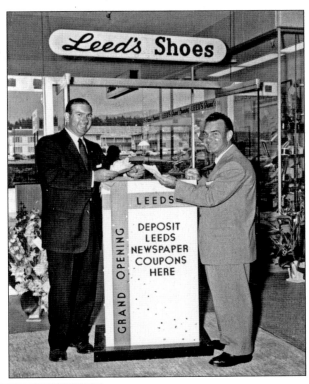

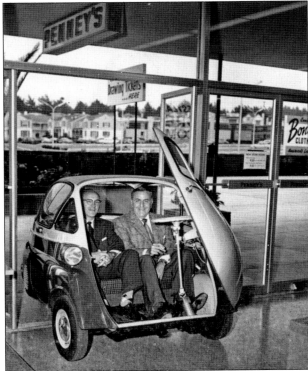

Giveaways continued into the fall as celebrations of Westlake's new stores brought crowds of shoppers to the area. Shown riding into Penney's in an Isetta, the first German car of its kind in the United States, are Penney's manager Donald Davis (left) and Henry Doelger, developer, in October 1956. A lucky Westlake shopper received the automobile. The vehicle had been used for several months as a tie-in with displays of casual and sportswear items.

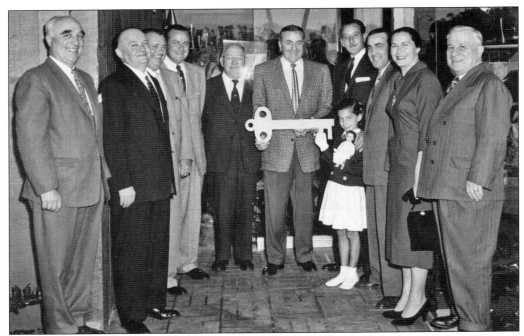

Opened in October 1956, Joe's of Westlake was designed by John Doelger, built for $200,000, and quickly recognized as the most popular dining spot in Westlake. When constructed, it was considered to be one of the most elaborate eateries in the Bay Area. Shown with restaurateur Bruno Scatena, right of "key to cuisine holder" Henry Doelger, are other fans of fine Italian food.

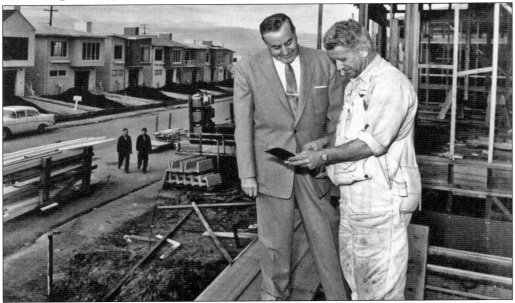

Doing what comes naturally, Henry Doelger checks details with construction supervisor Jack McKenna as new Westlake homes continue to be built. His hands-on interest in the work of the time gave witness to his evaluation of himself. Doelger is said to have remarked, "I think of myself as a builder."

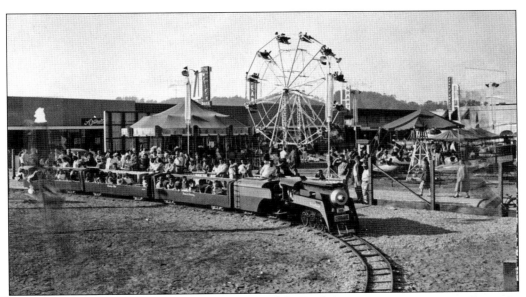

As the end of 1956 rolled around, so did the *Westlake Daylight* miniature passenger train, again making trips in Westlake Court for the delight of young passengers. Crowds of watchful parents stood by for photographic opportunities. The best view in town, of course, was from the top of the Ferris wheel.

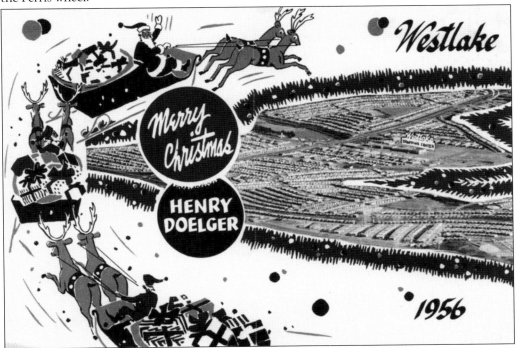

The population of Westlake had reached 16,139 by the time residents received this cheerful 1956 holiday greeting card. Visible to the right is the shopping center. During six and one-half years of construction, the area had endured topographical changes from a barren tract of dunes and dirt to a heavily developed community.

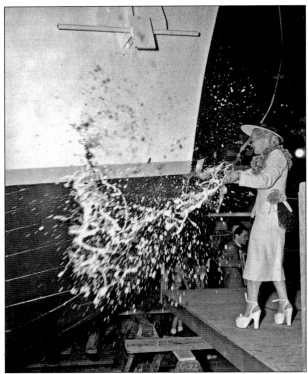

Making a splash with champagne was Thelma (Mrs. Henry) Doelger in 1957 as she christened the new *Westlake II* family yacht. San Francisco newspaper columnist Herb Caen noted, "Westlake II was built in Germany, registered in Liberia, and is sailed by a Mexican crew. . . . Now goggling eyes down at Yacht Harbor, the ship is ready to go anywhere anytime with a minimum of discomfort. . . . Her hold contains 200 cases of Scotch!"

Henry Doelger's hospitality flag flapped in San Francisco Bay breezes as the *Westlake II* hosted this unidentified trio of somewhat grim passengers in 1957. Unmistakably Doelger's yacht, the "tall one" on the flag boasted "H" and "D" on either side of its oval image.

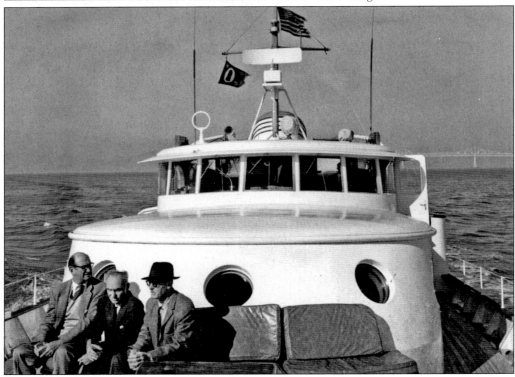

All hands feel safe
When our Skipper's
at the wheel.

When he is at the helm
It's on an even keel.

"Anchors Aweigh!" he
commands, "Everyone's
aboard."

"The Skipper" was heading for the high seas when this whimsical "Happy Birthday" portrait was created by an unknown artist. Thirty-nine Doelger well-wishers signed the card.

Bank of America was still waiting for neighboring buildings to be constructed in the Westlake Shopping Center court area when the February 1957 automobile show was hosted in the mall. Fully in use was the Medical-Dental Building to the right.

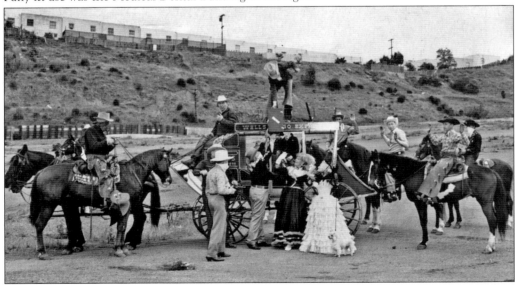

There were bad dudes in Westlake as this Wells Fargo stagecoach was detained and "robbed" of its mail pouch for the sake of a photographic opportunity in August 1957. The passenger with the ruffled white gown was Thelma Doelger. The event noted a new schedule of local mail service. Others shown include, in no particular order, Mrs. William Zappettini, Hy Rosenstein, J. M. Pisani, Sal Casalli, and Lennie Matson.

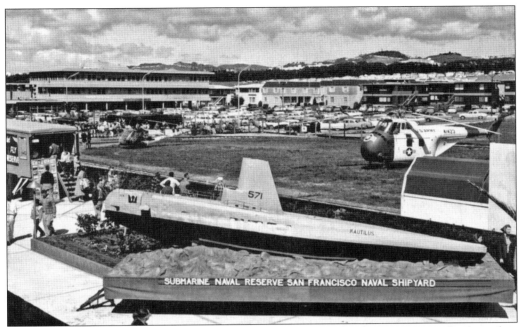

A military presence was welcomed to the undeveloped area of the shopping center for three days in March 1957 as the armed forces were celebrated. Promotional attractions included helicopters complete with rescue teams and parking lot bunkers with demonstration machine guns.

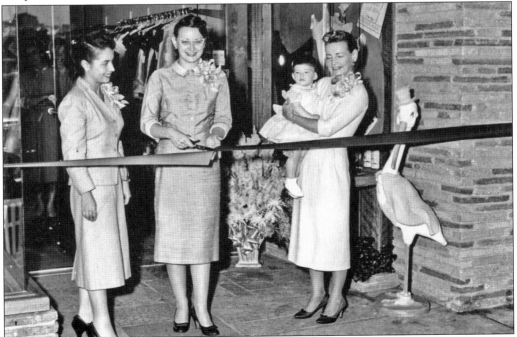

Possibly the stork that delivered this beautiful tot was on hand to help welcome Westlake's new Fern Warner Maternity shop. Shown from left to right are Fern Warner, Joyce Michel, little Leslie Michel, and Jane Doelger.

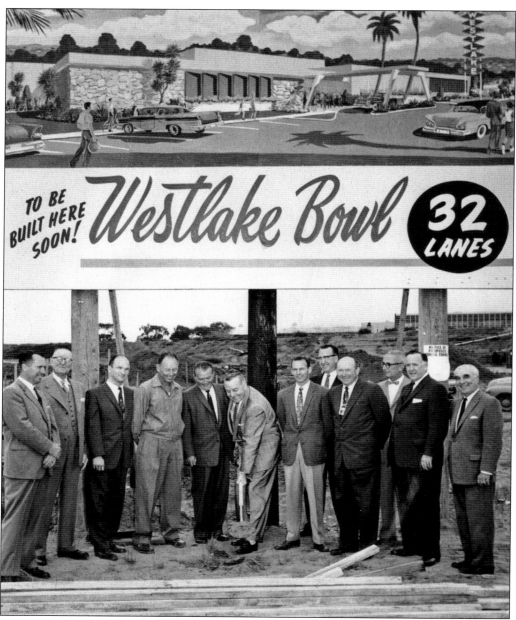

Unearthing the first shovel of dirt during the July 1958 ground-breaking ceremony for Westlake Bowl was Henry Doelger as project officials anticipated the 32-lane sports facility. From left to right are James Grealish, who would serve as the Bowl's general manager; Harry Christen; William Watson, chief architect; Carl Vedell; Bernardino Poncetta; Daly City mayor Michael DeBarnardi; Max Yaeger; John Swanson, owner of the Bowl; Jack Fairfield, construction superintendent; Lloyd Brown; and U. R. "Jack" Kendree, shopping center manager.

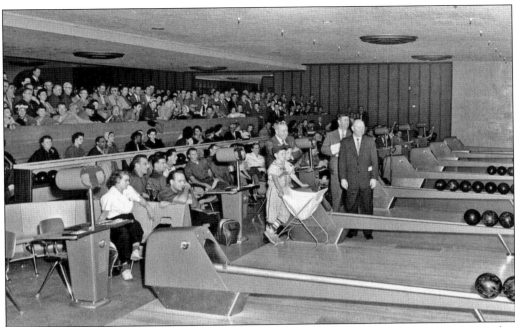

Bowling fans flocked to Westlake Bowl to take part in grand opening celebrations in December 1958. Celebrity and champion keglers demonstrated their skills, and prizes were awarded to lucky ticket holders. The facility offered the first back-to-back lanes in Northern California. For each pin toppled during lane-warming ceremonies, owner John Swanson donated $1 to the Daly City Police Athletic League youth program.

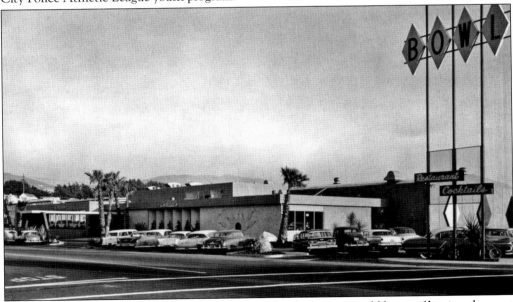

On completion, the ornate Westlake Bowl on Southgate Avenue could boast of having the most modern in Brunswick Automatic bowling equipment plus amenities ranging from a toddlers' lane and supervised playroom to locker rooms for patrons, a restaurant, cocktail bar, and snack service. In 2008, the site houses a Burlington Coat Factory store.

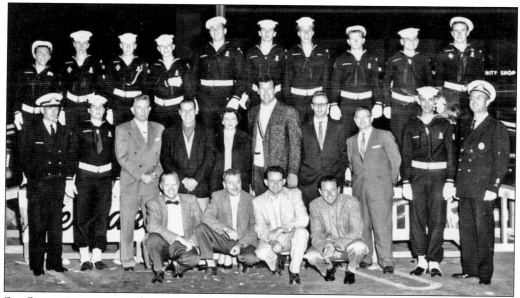

Sea Scouts in snappy uniforms were part of the security team when tots and their families were invited to Westlake Shopping Center to enjoy costume parades and fun. The tallest person in the photograph, in the center of the second row, is Daly City councilman Robert "Bob" St. Clair, Westlake resident and captain of the San Francisco 49ers professional football team.

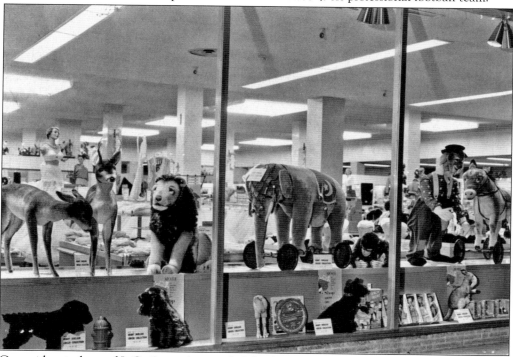

Courtside windows of J. C. Penney's provided display space for a few of Henry Doelger's circus animals and other childhood fascinations. It was the first public showing for the collection, most of which were brought from Europe by Doelger.

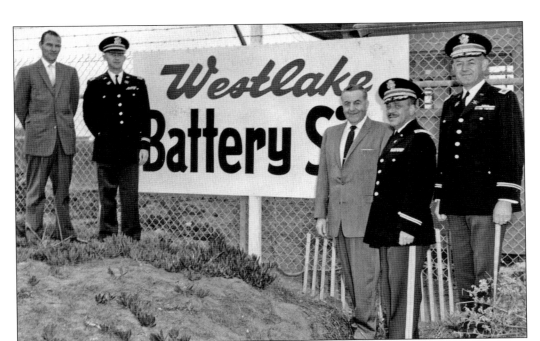

U.S. Army officials joined leaders of Daly City and Westlake in ceremonies marking the official designation in December 1958 of the Nike-Ajax guided missile site at Fort Funston, near the San Mateo–San Francisco county line. From left to right are Daly City mayor Michael DeBernardi; Lt. Warren W. Buckingham, unit commander; Henry Doelger; Col. M. M. Irving, 6th Region Air Defense commander; and Col. Iver A. Peterson.

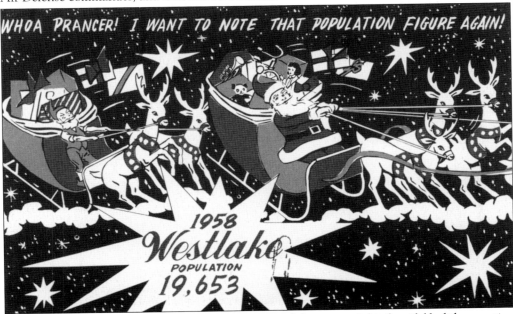

Continuing an annual tradition, householders in Westlake received this fanciful holiday greeting with a population update from the office of Henry Doelger, Inc., in 1958. Such vintage cards have become popular items for collection and holiday display.

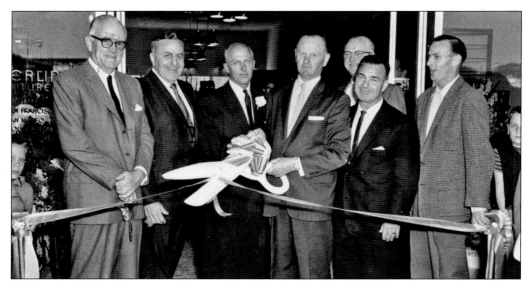

Sterling Furniture Company opened in Westlake in October 1959. Shown witnessing ribbon-cutting honors are, from left to right, Willis Hotom, chairman of the board; Henry Doelger; Peter Saxe; Daly City councilman Eddie Dennis; Rudi Richter; Daly City councilman Joe Verducci; and councilman Michael DeBernardi.

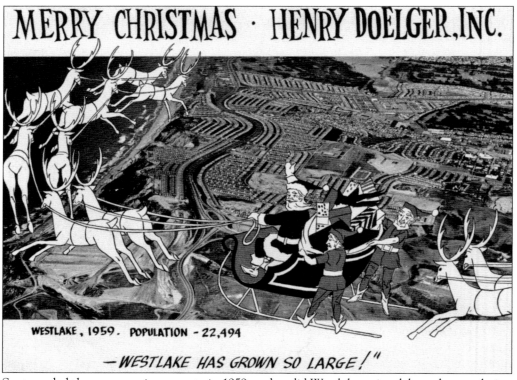

Santa ended the year on a joyous note in 1959, and so did Westlake as it celebrated a population of 22,494. Since 1949, when population was noted at 297, the growth of the area was remarkable. The background provided a fine image of north county development progress.

Five

GROWING PAINS

As a new decade opened, Westlake experienced suburban growing pains. The developer had built a sprawling residential community of close to 8,000 homes and 2,000 apartment units. Westlake Shopping Center embraced 91 stores on 27 acres, with 400,000 square feet of retail selling space.

In the 1960s, the publication *Shopping Center Age* noted, "Westlake is boomingly prosperous, even in a highly competitive area where shopping centers cluster like galaxies in space." Nearby was San Francisco's Stonestown Shopping Center to the north. Daly City's Serramonte Shopping Center to the southwest would launch operations in the mid-1960s. The publication pointed out that the same buses and automobiles that brought shoppers and homemakers to Westlake could also carry them elsewhere to spend their money. Another 5,000 homes were under construction in Doelger's nearby Fairmont section. "The more the community expanded," it was noted, "the more acute became the problem."

Doelger's innovative solution was to open his first enclosed mall satellite shopping center. Skyline Plaza was a tidy area of 9.7 acres and 18 storefronts, plus a medical building with 12 offices. It anchored the highly trafficked corner of Skyline Boulevard and Westmoor Avenue, to the south of Westlake Shopping Center. The exterior was distinguished by a series of barrel-vaulted overhangs. *Shopping Center Age* wrote, "It is almost as unusual to see a pet hospital as part of a shopping center as to see a chic beauty shop cheek-to-cheek with a supermarket, but Skyline has both."

Three years after Skyline Plaza's 1961 opening, a Doelger spokesman was quoted as saying, "Square foot income from the center is well above that of the successful parent shopping center." An unconfirmed rumor described Skyline as successful to the point of being among "the highest dollar volume per square foot shopping centers in Northern California."

A second satellite center was already being planned. It would be located about a mile and a half south from Skyline Plaza in the developing tract of Fairmont.

Doelger, according to *Shopping Center Age*, had plans that could keep him busy for the next three decades.

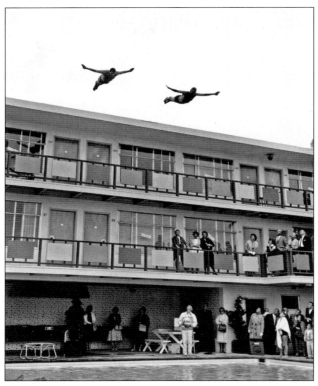

A splashy 1960 opening of the 75-by-30-foot Olympic-size swimming pool at Westlake's Coronado apartments brought aquatic demonstrations, swimmers anxious to try the water, and craning poolside observers. Shown diving from the roof are water sports champions Clyde Devine and his son. The $2-million building included 164 units with a monthly rental range starting at $94.50.

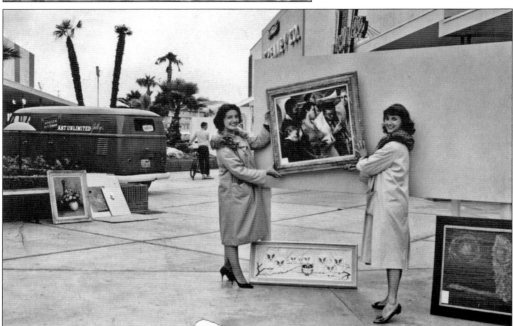

Art Unlimited brought a van full of eye-catching treasures to Westlake mall in the spring of 1960. Items such as the framed pieces shown were popular with those seeking to bring new decor into their homes.

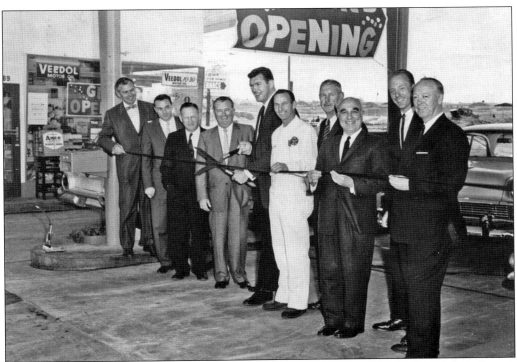

The grand opening of the Flying "A" Station at Westmoor and Southgate Avenues in August 1960 brought this lineup of happy drivers. From left to right are Tidewater Associated Oil Company officials D. E. Gordon and Phil Brown, Daly City city manager Ed Frank, Bernardino Poncetta, Daly City councilman Bob St. Clair, Daly City councilman and station owner Michael DeBernardi (in white coveralls), Tidewater official H. D. McCormick, U. R. "Jack" Kendree, Michael Morgan, and George Gavin.

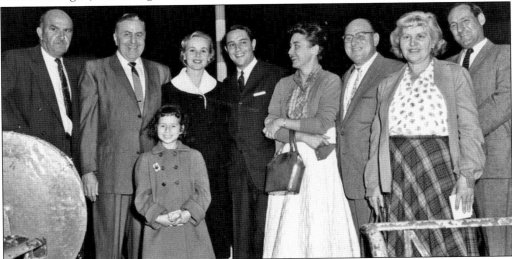

Judge Frank Blum (third from right) and Henry Doelger (second from left) were on hand to beam approval as winners of the September 1960 Back-to-School drawing were congratulated by Les Ritchie, president of Westlake Merchants Association.

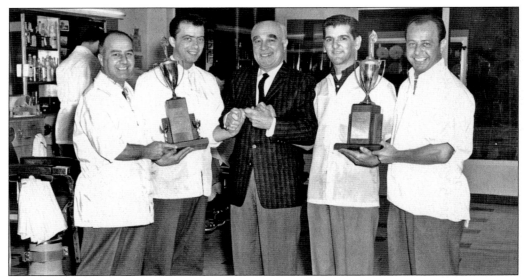

Westlake Barber Shop owners and employees were honored in October 1960 with Doelger corporation trophies attesting to excellence in business practices. The awards were presented by Westlake Shopping Center manager U. R. "Jack" Kendree. Shown at the extreme left and right are tonsorial experts Woody Green and Jack Green, respectively.

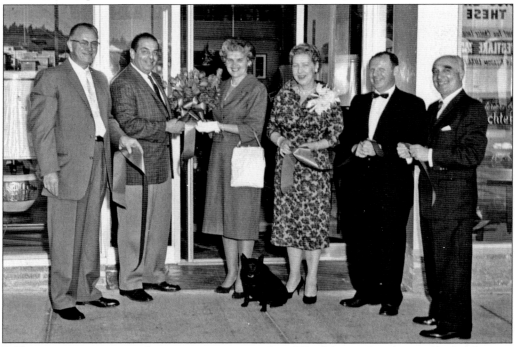

Ribbon cuttings continued as new stores opened in Westlake in October 1960. Celebrating the debut of Interiors by Richter are (left to right) Rudi Richter; Stan Sugerman, president of Westlake Merchants Association; Violet Richter; a representative of the Catholic Women's Guild; store manager Bob Fossom, and U. R. "Jack" Kendree. Other mall stores opening that month included the Jay Vee Store and Junior Boot Shop.

Santa was almost lost in the crowd of eager welcomers when he arrived with a basket of treats to distribute during his annual visit to Westlake mall in December 1960.

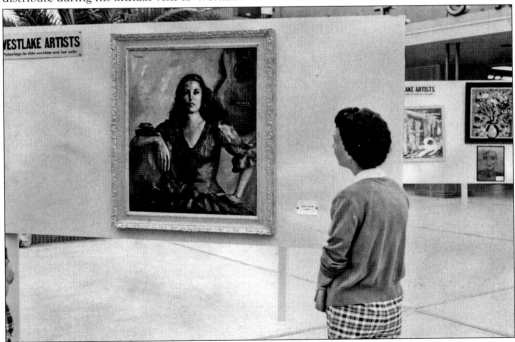

Among paintings exhibited at the April 1961 Art Fair in Westlake mall was this striking study of a musician with her guitar by Thelma Doelger. A prolific artist, Thelma Doelger often had her portraits and still-life creations displayed in Westlake model homes. Her work was also exhibited at the De Young Museum in Golden Gate Park and at art events throughout the Bay Area.

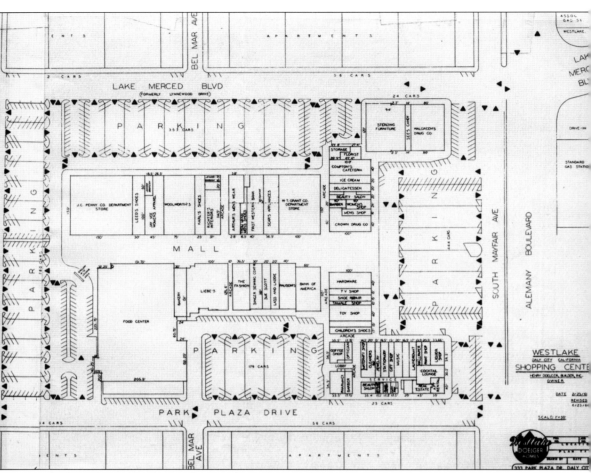

Shops and services clustered around Westlake mall as shown in this June 1961 map of Westlake Shopping Center business locations. Sterling Furniture, See's Candy, and Walgreen's occupied the top corner of the area while the food center dominated the diagonal bottom. Two-level apartment facilities to the west and east lined the center on Lake Merced Boulevard and Park Plaza Drive. Alemany Boulevard had not yet been renamed to honor early settler John Donald Daly.

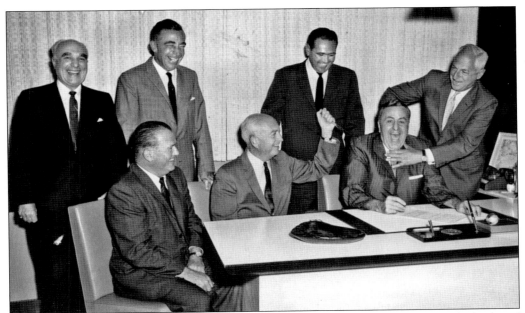

Signing a lease with representatives of H. Liebes and Company in June 1961 sparked a bit of levity during photographic documentation of the notable event. On either side of Henry Doelger are Lloyd and Sidney Liebes, whose family had operated the noted San Francisco fashion store since 1864, and, far left, U. R. "Jack" Kendree. The 15,000-square-foot Westlake location was to open in 1962.

Lucky winners of trips to Mexico in October 1961 were honored with the presence of Senor Obregon (center with certificates), representing the Mexican Consulate; Rudi Richter (left), president of Westlake Merchants Association; and (far right) U. R. "Jack" Kendree.

Ground was broken in September 1961 for the new H. Liebes store with help from a bulldozer. Holding an architect's rendering of the proposed facade of the building are, from left to right, U. R. "Jack" Kendree, realtor Hartford Rapp Jr., and architect Lloyd Gartner with Lloyd Liebes, realtor Samuel Blattels, and Sidney Liebes. Perched on the dozer are Henry Doelger and the amused operator of the vehicle.

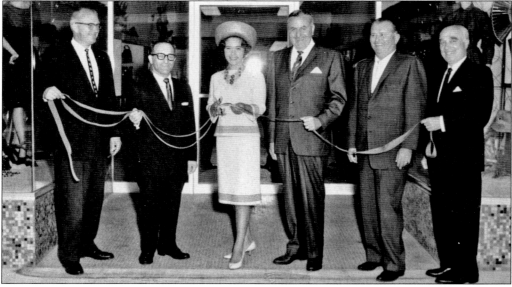

A pretty local lass was on hand for the opening of the Lass and Laddie Store in the fall of 1961. Shown from left to right are Rudi Richter; Irving Scott; Susan Doelger; Susan's proud father, Henry Doelger; Bernardino Poncetta; and U. R. "Jack" Kendree. Soon to follow were ribbon cuttings for Crocker Anglo National Bank, Pauson's Men's Clothing, and Home Mutual Savings and Loan Association.

Again welcomed to Westlake for his annual visit was Santa, who chose to stow some of his valuable 1961 holiday gifts in the Bank of America's vault for safekeeping by local branch manager Ed King and helper Shirley Fischer. In March 1962, King would become corporate vice president and general manager for Henry Doelger Builder, Inc.

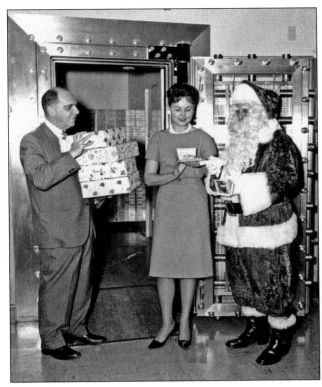

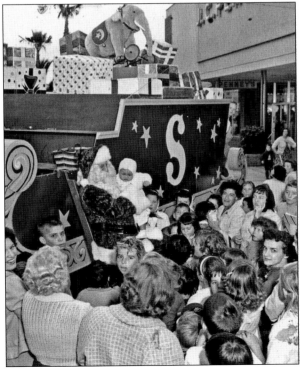

Almost dwarfed by his gigantic sleigh full of toys and holiday surprises is the jolly elf himself, as the vehicle—free of North Pole snow—arrives at Westlake mall in December 1961.

Marlene Schmidt, Miss Universe 1961, posed prettily when local editorial offices opened in 1962 for the *Westlake Post*, a weekly newspaper to be delivered throughout north San Mateo County. Monte Dayton, an obviously happy newsman, welcomed the fräulein from Germany to the north county office of the *San Mateo Times*.

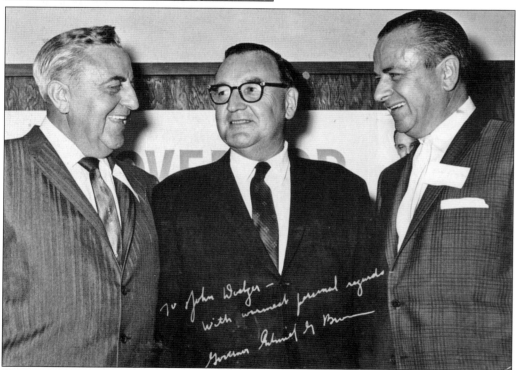

"Warmest personal regards" were penned by California's 32nd governor, Edmund G. "Pat" Brown (center), on this photographic souvenir of a pleasant visit. Shown with the 1958–1962 governor are Henry Doelger (left) and John Doelger. A native San Franciscan, the governor was among admirers of San Francisco's Doelger brothers, who had achieved fame for their home-building successes throughout the Bay Area.

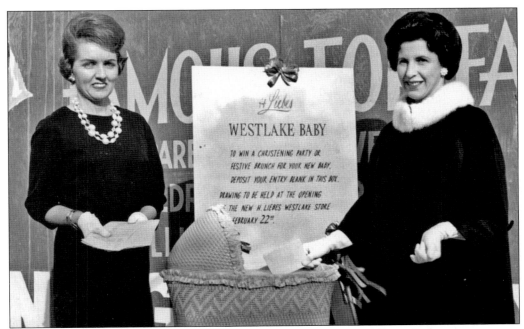

Westlake Catholic Women's Guild members Dorothy Burns and Rose Fraher were among those depositing entry blanks to win a festive brunch or christening party honoring the arrival of a new Westlake baby. The February 1962 drawing was sponsored by the newly opened H. Liebes store.

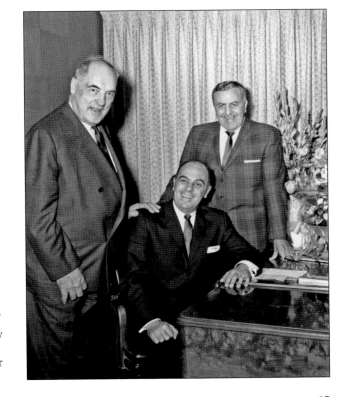

Floral tributes and executive smiles were displayed in March 1962 as Edward M. King was congratulated on his first day as a vice president of Henry Doelger Builder, Inc. Carl Wente, Bank of America president, rests a friendly hand on the back of the former Bank of America branch manager while Henry Doelger approves.

"Aloha" and congratulations were given to Mr. and Mrs. Schwerwood (center) in March 1962 when their lucky ticket was selected in a Westlake Shopping Center drawing for a trip to the Hawaiian Islands. Making the presentation of travel documents was Rudi Richter and, at right, U. R. "Jack" Kendree.

Even future patrons, including this tot with an icing mustache, celebrated Westlake Shopping Center's 11th year in June 1962. Through several decades, treats for mall visitors and shoppers recognized various holidays and milestones. Freebies included cherry pie on Washington's birthday and chocolate eggs at Easter.

Henry Doelger was still very much the man with the plans in the 1960s. He took pride in continuing to be Westlake's "hands on" builder.

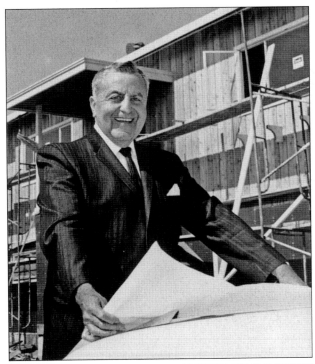

Typical of the wider-than-most homes in the Westlake Estates unit near the Olympic Club was the residence envisioned in this architectural depiction of homes on the planning board. Both the Estates and the Terraces would be completed in 1962.

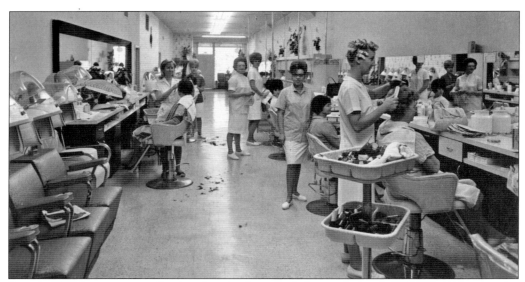

Busy as a beehive creating "beehive" and other trendy hairstyles in the 1960s was the popular Georgette's of Westlake Beauty Salon, with 17 uniformed operators ready to make stunning the ladies of the area. Shown at the center is Yvonne Marignac, mother of Georgette Sarles, who would become owner-operator of the salon. Services of the shop would later be expanded to offer beauty supplies and accessories.

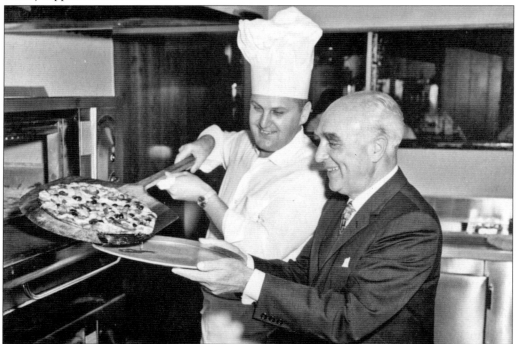

Fresh from the baking oven was one of the first taste temptations available at Westlake Pizza Shoppe, which opened for business in July 1962. In this photograph, chef Norman E. Markel slips a well-laden pie onto a service platter for U. R. "Jack" Kendree, manager of Westlake Shopping Center.

"West-lake Shop-PING Cen-ter," Westlake's clever six-syllable promotional ditty, was heard often during the 1960s. Both radio and television advertising spots featured the little jingle. It was also heard over speakers placed throughout the court, sometimes as lead-ins to announcements of specials being offered to shoppers and strollers. "Thumbnail" visuals were perfected by Westlake's advertising office. (Courtesy of Mike Scott.)

The Westlake chapter of the Camp Fire Girls donned their rainbow-colored aprons to serve generous portions of cake for Westlake's June 1962 anniversary celebration.

Clarabell the Clown, one of the most recognizable of children's entertainers in the 1960s, was a favorite in Daly City as well as on television's *Howdy Doody Show*. Never photographed without his/her distinctive makeup, Clarabell communicated only by exaggerated body language and by honking a horn for "yes" or "no." Clarabell's Westlake appearance was hosted by Thom McAn shoe store.

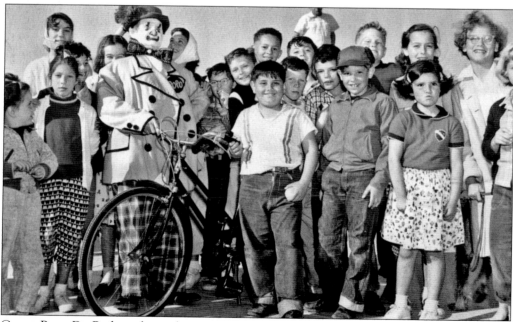

Count Popo De Bathe, whose clown career spanned 60 years, toured the world on behalf of children's programs sponsored by the United Nations. He appeared in Westlake several times to help distribute drawing prizes, including new bicycles for lucky ticket holders. The resident clown at Oakland's Fairyland, Popo appeared annually at the San Mateo County Fair.

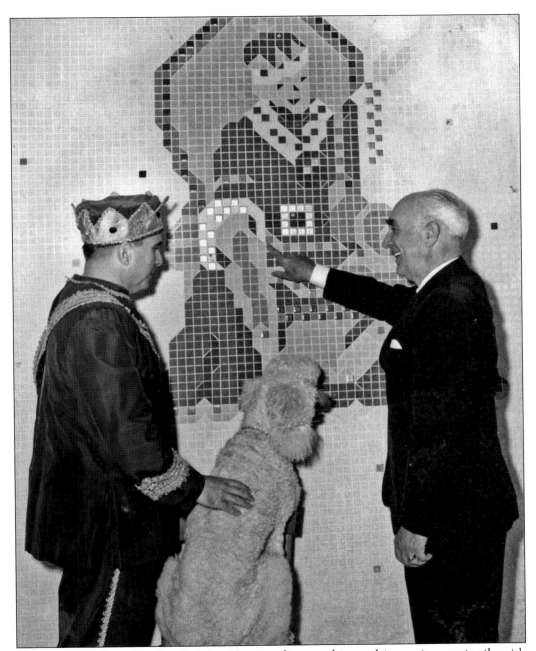

Resplendent in his official garb, King Norman discusses his regal image in mosaic tile with U. R. "Jack" Kendree. Toyland-type murals on exterior walls were unveiled when Norman opened his Westlake Kingdom of Toys store in August 1962. Supervising the exchange is Miss TeeVee, the King's furry companion at the store and on his 1954–1961 KGO television show. Well remembered by baby boomers, the King, seldom seen without his crown, was in reality Norman Rosenberg.

Automobile shows in Westlake Court annually attracted families and car coveters. This November 1962 event previewed 1963 vehicles. Stores on the west side of the mall included Arthur's Clothing Store for Men, Thom McAn Shoes, First Western Bank, Sears Appliances, and W. T. Grant Variety Store. On the east side of the court was Bank of America.

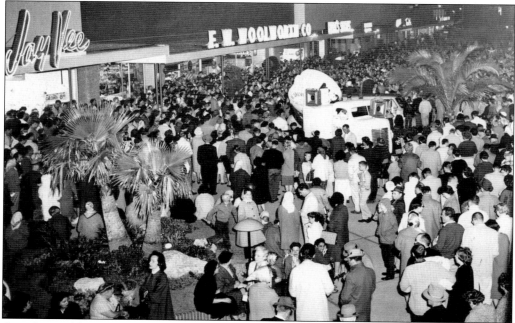

Crowds sizeable enough to please any merchant were on hand to witness the drawing of lucky tickets in November 1962 when Westlake Shopping Center's "Fall Travel Fair" was presented. Spotlights lit the skies, alerting the area to action in Westlake.

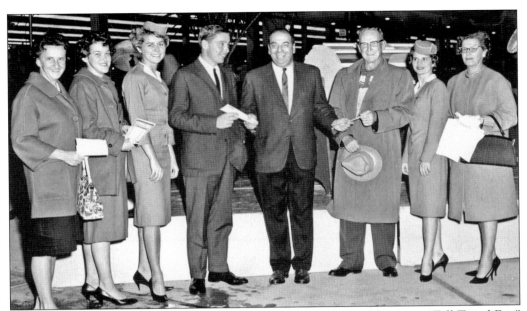

Westlake Merchants Association president Stan Sugerman (center) beams as "Fall Travel Fair" winners were presented with their prizes in November 1962. John Bogardus received a round-the-world trip. Runners-up received travel to Hawaii. PanAm airline stewardesses were on hand to witness the festivities.

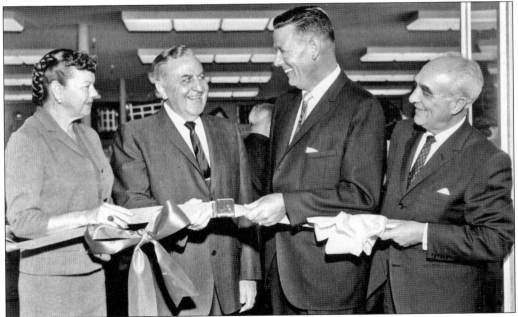

New stores continued to open in Westlake, while others moved their wares to larger or more advantageous locations within the center. Opening in December 1962 was a branch of the Auto-Torium. Shown from left to right are Mrs. Sidney Paton; Henry Doelger; Sidney Paton, owner of the chain; and U. R. "Jack" Kendree. An automobile seat belt was used instead of a traditional ceremonial opening ribbon.

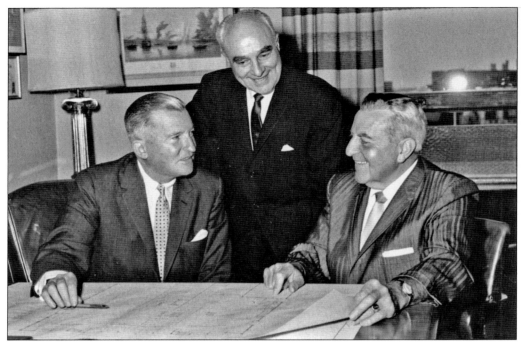

Westlake made major business news headlines in the winter of 1962 as a lease was signed that would bring a $9-million branch of Macy's to the area. Ernest L. Molloy (left), president of the California division of the national department store chain, signed documents in the presence of U. R. "Jack" Kendree and Henry Doelger. The proposed opening, never realized, was to be in 1963. Macy's opened its Daly City store in October 1968 at Serramonte Shopping Center.

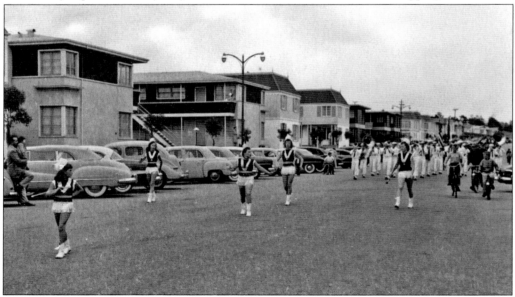

Parading past Westlake apartments on Park Plaza Drive, adjacent to Westlake Shopping Center, was this attractive group of pleasant-day marchers. Identities of the participants and the reason for the parade have been lost to history.

Six

RUMOR BECOMES REALITY

On January 20, 1965, Henry Doelger confirmed a rumor that had been circulating throughout the real estate world for weeks. His multimillion-dollar Westlake Shopping Center was being sold. The news was given a banner headline in the "Business World" section of the *San Francisco Chronicle*, important headlines in the business section of the *San Francisco Examiner*, and front-page stories in the *Daly City Record*, *Westlake Times*, *Westlake Post*, and *Half Moon Bay Review*. Actual transfer to the new owner would be completed by late March.

Official announcement of the sale came from the Doelger office: "Sale of the Westlake Shopping Center in Daly City, second largest shopping center in San Mateo County, along with a multi-million dollar expansion program which would bring the total transaction to more than $10 million was imminent today as negotiations between owner Henry Doelger and James H. Trevor of Burlingame reached the advance stage."

The sale, when completed, would mark one of the largest shopping center transfers ever made in Northern California. The prospective owner, a native San Franciscan, owned and operated shopping centers throughout California, including Studio Village Shopping Center in Culver City.

The Westlake sale would include 64 stores, office buildings, the Medical-Dental Building, the mall, and the parking area. The land parcel was equivalent to 16 city blocks, bounded by Southgate Avenue, Park Plaza Drive, South Mayfair Avenue, and Lake Merced Boulevard.

Doelger management would continue to hold 18 stores on Southgate Avenue, service stations, 2,500 apartment units, and restaurants, including Lyons and Joe's. Doelger said the reason for the proposed sale was to allow the entrepreneur more time to devote to his $500-million projects on the San Mateo County coastside.

In years to come, Westlake homes would continue to be desirable, attractive, and affordable. Westlake and Skyline shopping centers would endure states of decline and eventually experience dramatic changes by new ownerships.

Even so, Doelger had realized his early wish to develop into dwelling places the sand dunes of the San Mateo County coastline and establish a unique place for himself and Westlake in the history of Northern California.

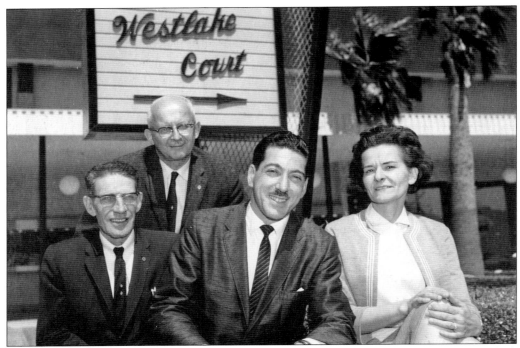

Officers of the Westlake Merchants Association in 1963 included Vice President Robert Morford, Treasurer Leo van Lougher, Pres. Bert Feltington, and Sec. Tilly Green.

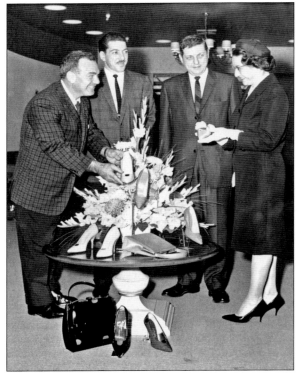

Bloom's Fine Shoes were welcomed to Westlake in February 1963. Shown from left to right are Joe Verducci, Daly City mayor; store manager Bert Feltington; Maxwell H. Bloom, store owner; and an unidentified happy door prize winner. Westlake was the eighth among Bloom's chain of stores.

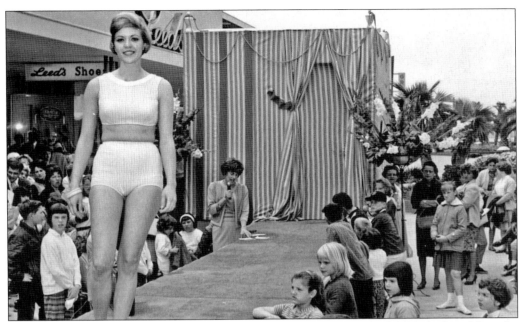

Cozy coats and sweaters were worn by viewers, but this runway model felt little cold as she paraded in Westlake Court for the annual Penney's Swimwear Fashion Show. The lady with the somewhat shocking bare-midriff swimsuit was a student at San Francisco's House of Charm modeling school.

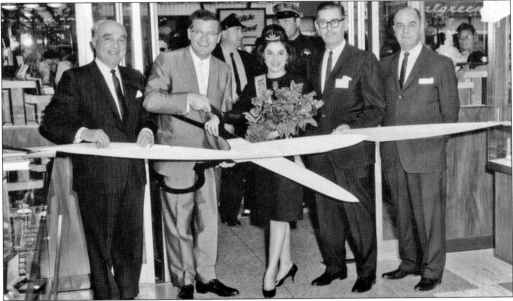

Miss Daly City of 1962, Susan Thorne, complete with her tiara and an oversized armful of roses, provided a touch of royalty as Kay Jewelers opened in April 1963. The store was Kay's 175th store nationally and the 23rd in Northern California. Shown from left to right are U. R. "Jack" Kendree; Alvin Glass, California supervisor for the chain; Thorne; store manager ? Manzini, and Edward M. King, vice president of Henry Doelger Builder, Inc.

Art on the mall brought aficionados and creative people displaying a variety of talents to Westlake mall for the May 1963 annual art fair. Potters, jewelry workers, weavers, and other artisans gave visitors close-up introductions to their artistic skills.

November 1963 brought huge, hopeful crowds to Skyline Plaza as the shopping center hosted the giveaway of a Ford Falcon automobile. In addition to the Falcon, 14 wristwatches and a $150 barbecue set were given to lucky shoppers. The gathering was estimated at more than 5,000.

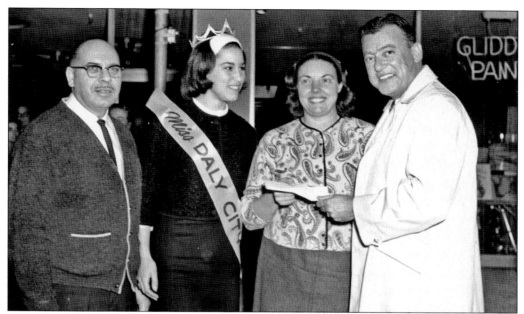

Pretty Claudia Smith, Miss Daly City for 1963, was present with her satin sash and crown perched above her headband as prizes were presented at Skyline Plaza's November giveaway of a Falcon automobile. Shown from left to right are Ray Forcina, president of the Skyline Merchants Association; Smith; Betty Kapovich, the happy ticket holder; and Gene Perry, advertising and promotion director for Henry Doelger Builder, Inc.

Santa Claus made his annual visit to Westlake mall in December 1963 to chat with children and distribute candy canes. Even the bountifully bearded genial gentleman, whose local headquarters were in the center's carousel booth, couldn't entice a smile out of this uneasy tot. Santa was portrayed by Solly Hoffman.

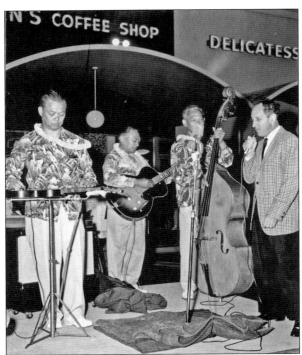

The Hawaiian Starlighters Trio, directed by San Francisco bandleader Sal Carson (right), were among the entertainers when Skyline Plaza shopping area celebrated an anniversary in May 1964.

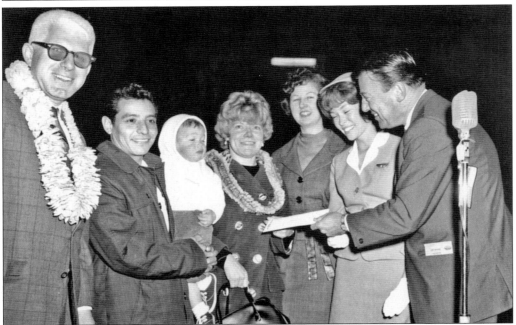

A weeklong, all-expense Hawaiian holiday for two was won by Mr. and Mrs. Luis Otanez, a high point of Skyline Plaza's annual birthday celebration in May 1964. From left to right are Richard Kamian of the Doelger advertising department; Luis Otanez; young Christopher Otanez; Mrs. Otanez; Mary Taylor, United Air Lines special events representative; Diane Lyons, United Air Lines stewardess; and Gene Perry, also of the Doelger advertising and promotion department.

Over 65,000 tickets were dropped into hoppers for Westlake Shopping Center's prize drawing on July 31, 1964. Thousands watched and hopes ran high as U. R. "Jack" Kendree called out the winning number and Gene Perry kept a lookout for the lucky shopper. The prize was a 1965 Ford Mustang automobile. The winner, not present at the drawing, was Betty Luksic, a San Francisco nurse.

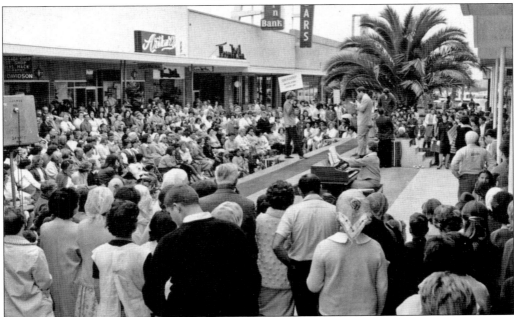

Back-to-school, teenage, and collegiate fashions were viewed as sign-bearing models paraded on a raised platform in Westlake mall in August 1964. Master of ceremonies for the event was television star Dick Stewart. Longtime Westlake resident Ivyle Lederer is at the organ. The event attracted over 1,500 shoppers and strollers.

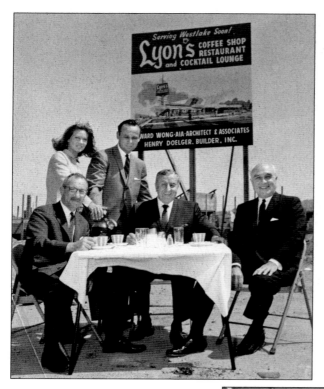

Silver service and a white linen tablecloth helped to herald the proposed development of Lyons restaurant in September 1964. Located near the intersection of Poncetta Drive and Alemany Boulevard, the $1.5-million facility was to open in January 1965. Temple Judea occupied the site before moving to Brotherhood Way. Celebrating in style were Karen Soltau, Miss Daly City for 1964; Gary Nachmann, Lyons vice president; J. H. Voorsanger, president; Henry Doelger, president of the firm that would build the restaurant; and U. R. "Jack" Kendree, director of Doelger Enterprises shopping centers.

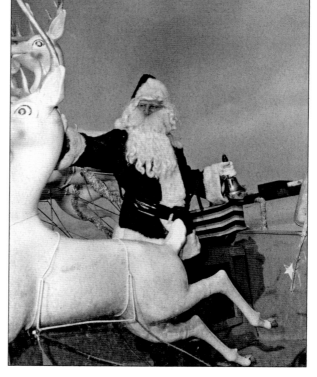

Back again for his annual stop in Westlake was Jolly Old St. Nicholas as portrayed by perennial favorite Solly Hoffman. In 1964, Santa saluted welcomers with his oversized handbell as his oversized sled was pulled by oversized white reindeer. An estimated crowd of 5,000 children, with their parents, greeted his arrival.

Sal Carson, holding his trumpet and wearing his traditional white hat, led his popular combo in holiday tunes as they entertained at Westlake Shopping Center in December 1964. Carson's musicians entertained many times over the years at Westlake promotional events.

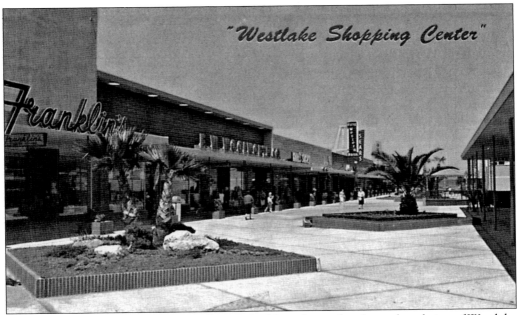

Brick planters, a gazebo, and a few strollers are visible in this undated postal card view of Westlake mall. Although an early view, as indicated by the immaturity of the palm trees, the sparseness of pedestrians and shoppers might have been omens of future times when the shopping center was to experience store closings, removals, and declining patronage. (Courtesy of author.)

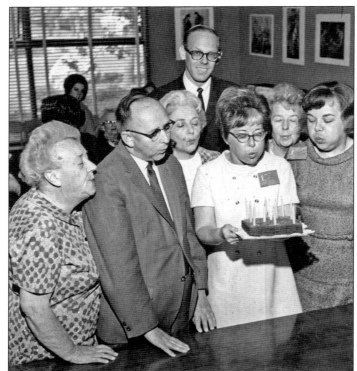

Friends of the Daly City Library gathered in the Coral Room at Westlake's branch of the library to celebrate their organization's 11th birthday anniversary in 1967. Shown from left to right are Lillian Fletcher, Daly City librarian Samuel Chandler, Gertrude Kendree, reference librarian David Crain, cake-holder Mrs. William George, and Maude Hanselman. The man in the background is unidentified. (Courtesy of author.)

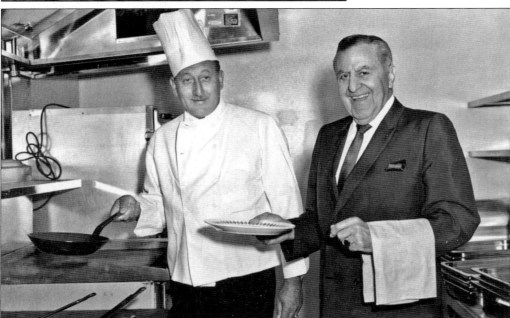

Fine Italian cuisine was on the minds of restaurateur Bruno Scatena (left) and Henry Doelger in this March 1967 photograph documenting the opening of Scatena's new Golden Coach restaurant. The eatery would bring delicacies of Joe's of Westlake, opened in 1956, to Fairmont Shopping Center.

Henry Doelger (in light jacket) smiled enigmatically for this October 1968 photograph during opening day ceremonies welcoming the Skyline branch of the First National Bank of Daly City. Others in the lineup (left to right) are U. R. "Jack" Kendree, Ricco Lagomarsino, Peter Markovich, ? Monson, Michael Doelger, Evert Terminello, Dr.? Westland, and ? Littlejohn.

The Bartels and Blaine drive-in restaurant chain opened its newest A&W at the corner of Alemany and Lake Merced Boulevards in Westlake in October 1968. Ceremonial ribbon holders are (left to right) Henry Doelger, former Daly City mayor Francis Pacelli, Ray Bartels, current Daly City mayor Bernard Lycett, Lyle Blaine, and Michael Doelger.

In 1972, after almost a quarter century of seeing fields and farms developed into Westlake, Henry Doelger retired from active business involvement to travel and enjoy his boat, his home, his ranch, and his family. The community of Westlake wished him happiness.

Standing tall in the mall in 1974 was Westlake resident and football star Bob St. Clair with local luminaries. Francis Paccelli (left) and Tony Giammona flank the 6-foot, 9-inch athlete from their perch atop planter bricks. Also shown, from left to right, are Victor Kyriakis, Ed Dennis, and Michael DeBarnardi. All were Daly City councilmen over the years. St. Clair was mayor of Daly City in 1961 while he captained the San Francisco 49ers. He would be named to the Pro Football Hall of Fame in 1990.

Free electronic announcements on Westlake's display board in the north parking lot were provided for community-based nonprofit organizations and activities. Among those inviting readers to their public meetings was the History Guild of Daly City/Colma. Westlake Merchants Association provided the ongoing informational service. (Courtesy of Ken Gillespie.)

The farewell to a favorite men's outfitting store in the Westlake Mall was heralded by huge window-blocking signs as the proprietor of Arthur's Store for Men opted to retire from business in November 1986. The popular shop offered many amenities for its customers, including alterations, gift wrapping, and an easy return policy. The store opened in March 1956, having relocated from the West Portal district in San Francisco. (Frank Franceschini photograph.)

Westlake residents were congratulated by neighbors when they were named king and queen to reign over Daly City's 1986 year-long celebration of its 75th anniversary of incorporation. Shown from left to right are Elaine Riney, "Queen" Esther Appleton, Walter Riney, and "King" Hartley Appleton. The Appletons had lived in Daly City since 1931. All were among the earliest residents of Westlake's Unit No. 1. (Courtesy of the Appleton estate.)

North San Mateo County Sanitation District launched expansion of the wastewater treatment plant in Westlake Park with a ground-breaking ceremony in July 1987. Among Daly City officials digging in to help are, from left to right, Dave Rowe, city manager; and council persons Albert Teglia, Jane Powell, James Tucker, and Anthony Giammona. In the background, Daly City city clerk Lorraine D'Elia (far right) and others look on with approval. (Courtesy of Ken Gillespie.)

Eerily and photographically superimposed is this striking July 1990 image of participants in a historical re-enactment at the Broderick-Terry Duel Site Park in the Estates area of Westlake. Shown from left to right are Dr. Robert Chandler, Wells Fargo historian; Ken Gillespie, Daly City historian; Geno Fambrini, who portrayed 1859 duelist Judge David Terry; and Richard Hill, portrayer of the ill-fated Sen. David Broderick. Note the historical pylon to the right. The event was presented by the History Guild of Daly City/Colma. (Courtesy of author.)

Four former Miss Daly City title holders were reunited at the Doelger Community Center in Westlake Park in May 1996 when they spoke of their reigns at a History Guild of Daly City/Colma meeting. Shown from left to right are Dorothy Barrigan, 1978; Diane Wagner, 1971, and Miss California 1972; Diane Albee, 1976; Guild president Ken Gillespie; and Lynette Fischel, 1961. The center utilizes the former Fernando Rivera school site. (Courtesy of author.)

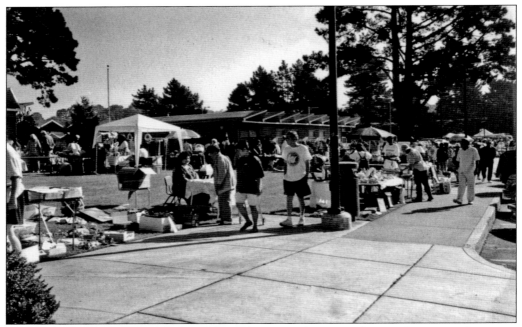

Flea markets and rummage sales have always been popular among bargain hunters and amateur entrepreneurs. This sunny September 1998 scene brought dozens of vendors and hundreds of buyers to the lawn adjacent to Doelger Community Center in Westlake Park. Space rental benefited the center. (Frank Franceschini photograph.)

Reopening ceremonies for the Westlake branch of the Daly City Public Library on Southgate Avenue were held in September 1998. The building received major renovations in the 1990s after almost 50 years of use. Dedicatory remarks from dignitaries included a keynote address by the California state librarian, Kevin Starr. Modernization had required approximately $200,000 more than officials had originally planned and took over a year longer than had been estimated to be completed. (Frank Franceschini photograph.)

Seven

THE MILLENNIUM
ARRIVES

The millennium year of 2000 arrived with hoopla, fireworks, and promises of momentous changes within the Westlake community.

In 2002, the Doelger family's Westlake residence would be advertised for purchase and vast changes were predicted for Westlake Shopping Center. From its headquarters in New York, Kimco Realty Corporation announced that it would henceforth own and redevelop Westlake Shopping Center.

A cadre of sidewalk superintendents made a practice of watching with wistful and wondering eyes the demolition of the Westlake Shopping Center they had known for some 50 years. Many merchants had padlocked their doors. Seagulls were often more plentiful than automobiles in Westlake parking lots.

Phoenix-like, however, as this chapter is written, Westlake is rising—not from the depths of the dunes as in the 1950s, but from the depths of moribundity that hovered as a miasma over the area during the decades just preceding. The mall's decor has been modified to accommodate a center thoroughfare and "Main Street" appearance with landscaping, benches, two-way vehicular traffic, and street-side parking. Many of Westlake's vintage palm trees have been relocated within Kimco's property.

Looking to the future, there are rumors of reinstating the Westlake flag atop one of the higher buildings, again to flutter a welcome to patrons. A sense of historic appreciation of the development is evidenced within several of the newer business establishments. A small selection of vintage historical photographs of the area may be viewed in Trader Joe's. Representational murals dominate the dining room at BurgerMeister. At the west end of John Daly Boulevard, the pathway at Thornton Beach Vista has informational signs referring to the location's history and its surrounds.

Elsewhere in Westlake, residences continue to be desirable, tidy, and affordable. Early in 2008, a feature story in the *Examiner* blared, "Once scorned, Doelger homes are now prized." Median sales at the time hovered around $687,000, about $60,000 higher than average homes prices throughout Daly City. A few Westlake homes were priced in the $800,000 bracket.

Westlake residences, an analyst noted, had become "iconic representations of mid-century design, with a growing following of design-conscious enthusiasts."

Doelger Art Center, formerly housing Olympia Elementary School, at 200 Northgate Avenue, is shown here in May 2000. Reconfigured into a studio and workshop hub for artistic creativity, the center is within easy walking distance to 1950s residences built on Northgate for the Henry Doelger family, friends, and officials of his corporation. School classrooms have been converted into rental studios and practice rooms. (Frank Franceschini photograph.)

Southgate Avenue, between Lake Merced Boulevard and Park Plaza Drive, received a new look in October 2000. Directly facing into Westlake Shopping Center, the two-level commercial block houses banks, restaurants, offices, and small businesses. Typical flat Doelger roof lines were replaced by gentle curves. (Frank Franceschini photograph.)

Paccelli Event Center honors the memory of Francis "Frank" Paccelli, Daly City businessman, entrepreneur, and sports enthusiast. Paccelli was elected to serve as a Daly City councilman several times and governed as Daly City mayor in 1960–1961 and 1965–1966. Nestled in Westlake Park, the building includes a large multiuse gymnasium and rooms for community gatherings. (Frank Franceschini photograph.)

Westlake Shopping Center was soon to embrace new commercial buildings and a central drive-through street when this photograph was taken in April 2001. Opening the area to vehicular traffic would replace the walking mall, a mecca for shoppers since the 1950s distinguished by palm trees, brick planter boxes, a gazebo, and backless benches. Business was disrupted by construction projects but not curtailed, as the sign indicates. (Frank Franceschini photograph.)

With the slogan, "Working Together for our Community," members of Daly City's Pilipino Bayanihan Resource Center shared information with Westlake mall visitors in October 2001 at its annual Fil-Am Friendship Celebration. The organization strives to make transition from the Philippines to the United States easier for newcomers. Shown from left to right are Rose Faulve, JoJo Lliangco, Monica Abello, and Perla Ibarrientos. (Courtesy of Perla Ibarrientos.)

In March 2002, the circular design of the Marjorie H. Tobias Elementary School, 725 Southgate Avenue, continued to attract the interest of architects, authors, and school planners. Designed by award-winning architect Mario J. Ciampi in 1957, the school's original name, Vista Mar, was changed to honor Tobias, a longtime Jefferson District schoolteacher and principal. (Frank Franceschini photograph.)

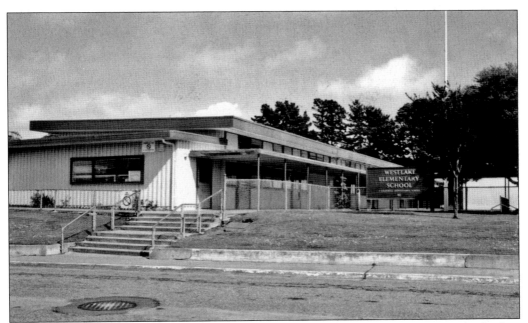

Basically unchanged in 50 years, Westlake Elementary School, 80 Fieldcrest Drive, was the first public educational facility constructed in Westlake. When this March 2002 photograph was taken, the campus had been in continuous use since it welcomed its first students in 1952. The building reflects the ubiquitous flat-roof style found in residences and businesses throughout Westlake. (Frank Franceschini photograph.)

Daly City's annual Gateway Festival, celebrating "A Community of Many Cultures," was launched in 1992 and held in various venues over the years. The June 2002 festival was the last to be presented in the Westlake mall because of impending redevelopment of the area. The event included live entertainment, display booths offering community information materials, ethnic foods, homespun crafts, and historical displays. (Frank Franceschini photograph.)

Constructed in the 1950s in the heart of the booming Westlake development, the uniquely spectacular residence of the Henry Doelger family, 112 Northgate Avenue, went on the market in 2002 for $1,250,000. Potential buyers were invited to "own a piece of history." The heavy vertical line of the chimney had been brought out from the front, breaking up predominating horizontal lines. The property, equivalent to three average Westlake lots, sold in March 2003, for $1,298,000.

The center of attraction in Doelger's imposing home was the kidney-shaped swimming pool with overhead illumination. Glass sliding doors separated the pool and its surrounding tiled lanai from the formal living room. Elaborate indoor plantings dominated corners. An atrium opened onto a patio overlooking Olympic Golf Club. In 1955, the *San Francisco Examiner* noted "the interior . . . is the sophisticated expression of playful taste, combined with a large chunk of the spectacular."

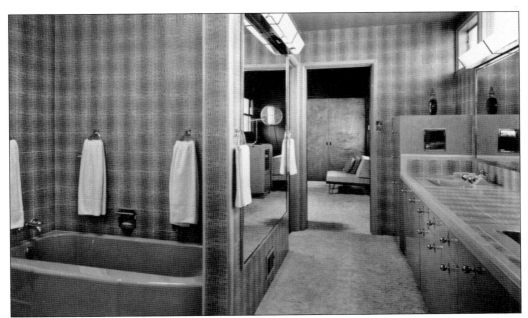

The bath in Doelger's two-room master bedroom suite boasted double facilities and was as large as the bedroom in many homes. The 4,660-square-foot living area of the house included six bedrooms, four and a half bathrooms, a large dressing room, a den, two children's rooms, an extra-large living room, and a sizeable dining room.

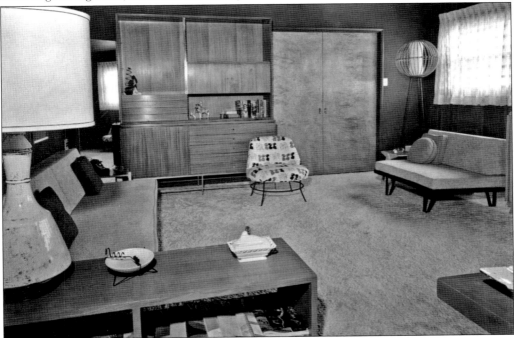

Adjacent to the master bathroom was Doelger's private study and den, which could be converted for use as a guest room. Close at hand was a private telephone line that connected the residence with the Westlake business office.

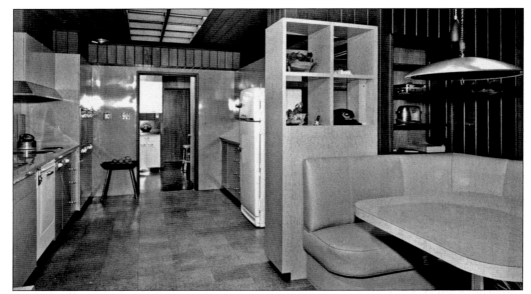

The kitchen of the Doelger house was located in the service wing, fronted by a spacious formal dining room walled in brick with seating under exposed rafters. In the rear of the house were the laundry and storage rooms, plus living quarters for a cook and a maid. The informal dining area at one end of the kitchen was reminiscent of club-car dining nooks placed in Sunset District homes in the 1940s.

The story is told that, when he was a child, Henry Doelger wanted a model railroad. He didn't get one. Years later, when he began to strike it rich, Doelger still wanted a train set. His hopes had changed over the years from wanting a push-around train to a wind-up train to an electric train. Shown above is the elaborate electrified model train layout installed in Doelger's Westlake home, evidence that he finally got his wish.

A gala Fil-Am Friendship Celebration was presented in June 2003 to the delight of Westlake mall observers. The event was sponsored annually by the Daly City–Quezon City Sister City Committee and presented in the mall until Westlake's central gathering area was remodeled. Among those participating in traditional ribbon-cutting and opening ceremonies were Georgette Sarles, Westlake Merchants Association president; Ray Satorre; Joey Cummings; Virgilio Talao; Daly City council members Adrienne Tissier and Carol Klatt; Mike Scott; Rollie Lavarias; John Warren, president of the Daly City–Quezon City Sister City committee; and Perla Ibarrientos. (Courtesy of Perla Ibarrientos.)

Filipino heritage dancers in colorful costumes delighted audiences as part of the on-stage entertainment provided by the Mahal Cultural Dance Group of the Bay Area during the June 2003 Fil-Am Friendship Celebration. The celebration also featured Filipino food, crafts, and musical entertainment. (Courtesy of Perla Ibarrientos.)

Stormy weather in February 2004 caused disastrous flooding and messy inconvenience to residents of Westpark Drive in the Westlake Estates section. Basements and gardens were inundated from seasonal rain and runoff water from nearby slopes, overtaxing sewers, storm drains, and the patience of homeowners. (Frank Franceschini photograph.)

Elaborately tiled in a checkerboard motif, the J. C. Penney store that had anchored the southwest corner of Westlake Shopping Center for decades felt the crunch of a wrecking ball shortly after this photograph was taken in autumn of 2004. Penney's had vacated the property a few years earlier. For short terms, the building was rented to other entrepreneurs. Kimco Development granted the site to Home Depot Design Center. (Frank Franceschini photograph.)

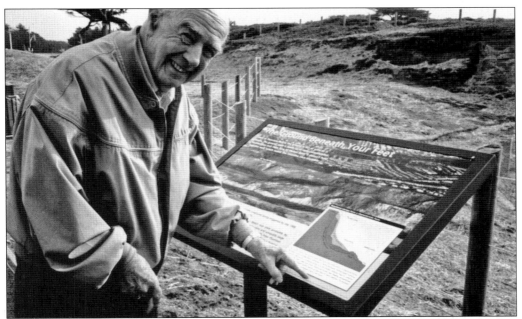

Unique in the north county, Thornton Beach Vista opened in October 2004 just west of the intersection of Skyline Boulevard and John Daly Boulevard. The beautiful spot was built within a former CalTrans right-of-way in a long-abandoned section of California State Highway 1 along the Daly City coast. Interpretive displays provide introductions to local history, flora, fauna, and landmarks. Local historian Ken Gillespie points to signage regarding "The Ground Beneath Your Feet." (Stephanie O'Dea photograph; courtesy of author.)

Spectacular sunsets and ocean views attract visitors daily to Thornton Beach Vista. Honoring the memory of 1853 settler Robert Sheldon Thornton, the vista has been open from dawn to dusk since October 2004. The $650,000 overlook includes benches placed along an easy walkway punctuated with this sculpted tree, reminiscent of Monterey's famed Lone Pine on the 17-Mile Drive. The Thornton Vista tree provides a romantic and inspirational focal point. Even local fogs fail to diminish the breathtaking view of the Pacific Ocean. (Frank Franceschini photograph.)

The first major store to open under the aegis of Westlake Shopping Center's new ownership, Kimco Realty Corporation, was Trader Joe's, a popular food market. Housed in a newly constructed building, Trader Joe's was relocated in November 2004 from the perimeter of the center and enlarged during phase one of Kimco's massive retail development activities. Accessible via escalator, Cost Plus World Market is housed atop Trader Joe's. (Frank Franceschini photograph.)

Continuing Westlake's tradition of ribbon cutting to mark the opening of business enterprises was this ceremonial activity welcoming Trader Joe's to its new location. Shown from left to right are Mario Panoringen, CEO of the Daly City/Colma Chamber of Commerce; Sal Torres, Daly City councilman; Robert Barnhill, store captain; and Georgette Sarles, president of the Westlake Merchants Association. (Ken Gillespie photograph; courtesy of author.)

Things were looking up when local leaders celebrated the opening of Westlake Shopping Center's new main thoroughfare for vehicular and pedestrian traffic between John Daly Boulevard and Southgate Avenue. Shown from left to right in this November 2005 photograph are Kimco redevelopment vice president Bill Brown and property manager Linda Larsen; Daly City council members Maggie Gomez, Judith Christensen, and Sal Torres; and Georgette Sarles, proprietor of Georgette's Beauty Salon and president of the Westlake Merchants Association. (Courtesy of Kimco Realty Corporation.)

BurgerMeister, one of the Bay Area's most popular hamburger chains, opened in March 2007 with flair, festivities, and fantastic food amid new stores in redeveloped Westlake. Shown from left to right at the debut celebration are Laurite Mogannam, owner Paul Mogannam, Rima (Mrs. Paul) Mogannam, Bill Lee, Daly City mayor Maggie Gomez, Daly City treasurer Tony Zidich, and California state assemblywoman Fiona Ma. The dining room features two large murals depicting scenic Westlake. (Courtesy of Paul Mogannam.)

Westlake Community Baptist Church, 99 Elmwood Avenue at Southgate Avenue, has the distinction of being the only house of worship whose name indicates that it is located in Westlake. Constructed in 1955, the building received its high tower in 2007. Not a bell tower, the structure hides electronics supplying services to the area. A heroic stained window at the main entry, depicting Christ kneeling, was donated by H. F. Suhr Mortuary. (Courtesy of Rev. Charles M. Northrop.)

Honoring the memory of Westlake's founder is a handsome sculpture displayed among rosebushes in the courtyard of Doelger Community Center, 101 Lake Merced Boulevard. Doelger died July 23, 1978, while touring in Italy. During his lifetime, Doelger neither sought nor favored such personal tributes. Reminiscent of the wording on a monument honoring the great architect of London, Christopher Wren, one might also remark of Henry Doelger: "If you seek his memorial, look about you." (Frank Franceschini photograph.)

The Doelger Homes logo has long disappeared from the scene in Westlake, but the memories linger on.

ACROSS AMERICA, PEOPLE ARE DISCOVERING SOMETHING WONDERFUL. *THEIR HERITAGE.*

Arcadia Publishing is the leading local history publisher in the United States. With more than 4,000 titles in print and hundreds of new titles released every year, Arcadia has extensive specialized experience chronicling the history of communities and celebrating America's hidden stories, bringing to life the people, places, and events from the past. To discover the history of other communities across the nation, please visit:

www.arcadiapublishing.com

Customized search tools allow you to find regional history books about the town where you grew up, the cities where your friends and family live, the town where your parents met, or even that retirement spot you've been dreaming about.